LIFE IN THE WILD

A Photographer's Year

LIFE IN THE WILD

A Photographer's Year

Andy Rouse

GUILD OF MASTER CRAFTSMAN PUBLICATIONS

First published 2002 by
Guild of Master Craftsman Publications Ltd,
166 High Street, Lewes,
East Sussex, BN7 1XU

ISBN 1 86108 268 1
A catalogue record of this book is available from the British Library
Map by Martin Darlison at Encompass Graphics Ltd

Designed by Fineline Studios
Cover design by Fineline Studios
Typeface: Meta

Colour origination by Viscan Graphics (Singapore)
Printed and bound by Kyodo Printing (Singapore) under the
supervision of MRM Graphics, Winslow, Buckinghamshire, UK

For Tracey, my partner in every way

Special and heartfelt thanks must go to the
following people – they have all provided
unwavering support and assistance over the
past few years:

Andrew Jackson, Tim, Mark and the staff at NHPA,
Joachim and Andrea at Wildlife, Nanda Rana and
Latika Nath Rana, Nigel at Lowepro, Paul, Mark and
Steve at Face TV, Navdeep Suri, Ahti Putaala,
George and Isabel, all our local guides (too many
to name), Chris G, John H, PVV, 'Mrs T', Bill Ryan
and Mick Reilly.

Foreword

There is a widespread misconception that wildlife photographers, as a group, are comprised largely of finicky but gentle men who potter slowly about their toils working from the back of those half-wooden cars, clad in country gear and, always, clean hiking boots. Well, they're not – as this book clearly illustrates. Rouse's forthright, honest, down-to-earth and even confrontational admissions redefine this stereotype admirably. Here is a businessman, entrepeneur, traveller, technician, labourer, author... and photographer whose coincidental passion for wildlife and great energy have combined to produce not a career, but a lifestyle.

This diary is not merely an evocation of the Rouse lifestyle, however, as scattered throughout are lots of very precise and practical tips that will prove invaluable to those seeking to emulate or replicate some part of this journey or its objectives – the little things that you might not think of are detailed in a host of helpful panels. More useful still are the detailed explanations of approach which will surely excite imaginations and ideas and stimulate readers to try it for themselves.

All-in-all, the text is novel, fresh and frank, a real rarity in this often too precious field of photography, but ultimately and essentially, the photographs say more than the rest combined. These brilliant images, selected from a few fractions of one year and from around the globe, tell the true story. Marvel, enjoy and be amazed, but then study them hard, not once but a hundred times each: such scrutiny will reveal not only the practice behind the art but also the spark that fuels such a life in the wild.

Chris Packham, Naturalist, Photographer, Broadcaster
April 2002

Contents

Introduction

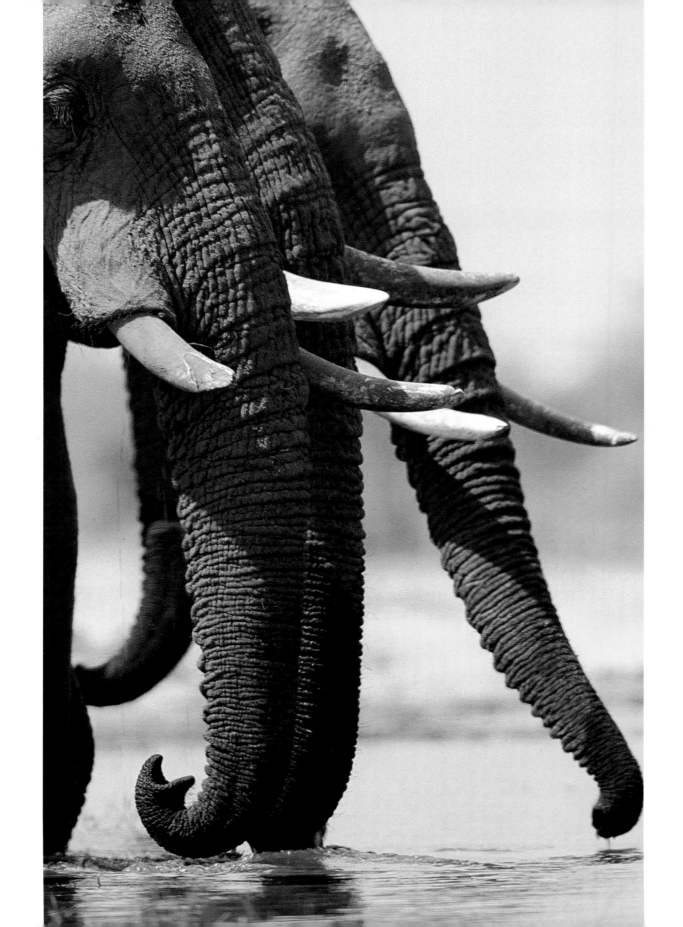

Introduction

My life as a wildlife photographer is one of tremendous contrasts. One week I can be watching the tender interaction between a polar bear family in the high Arctic, the next I am trying to sell the resultant images in today's ruthless business world. The latter is a necessary evil that comes with my chosen career. Career is a word I use cautiously for in reality it is much more than a job, it is a way of life for me and those I share it with.

The key to success as a wildlife photographer is to be a specialist in a particular area, whether it be mammals, birds, reptiles or whatever you may fancy. But as well as being a specialist, to survive, you need to be an opportunist too. My reputation has developed because I am mad enough to take pictures of many of the world's fiercest and most dangerous creatures. However, the fact that I travel to far-flung places and stare down the throat of a lion doesn't mean this is what makes me tick. To be a good wildlife photographer, yes you do need a certain amount of technical skill and an eye for a picture, but it is an inherent, all-consuming passion for wildlife that will make your images great and separate them from the rest. To know as much as you possibly can about the animals you are photographing is not only key to successful images but also your duty; you are a guest in their world and the 'leave only footprints' motto applies equally to our business as to any other. That's one of the reasons I get just as much of a buzz from snapping my local deer, or spending endless cramped and unpleasant hours in a hide to have a unique encounter with an elusive fox, as I do by tracking elephants or rhinos on safari in Africa. In fact, the skills I have learnt from getting close to the shyer animals have served me well with the more exotic species I come across.

It would be nice to spend your time enjoying your hobby as a way of life but wildlife photography is not a business for the faint-hearted. I do not have a rich sponsor or magazine commissions that send me to explore the Amazon basin. In this field, foreign commissions are becoming as rare as new hairs on my head. Instead, I am obliged to gamble on a daily basis, trusting that my skill with the box brownie will yield enough results to make foreign trips a financial success and keep the bank manager at bay.

I wrote this book to graphically illustrate the roller-coaster ride that constitutes my life. Share in the highs and lows, the ups and downs and twists and turns of life in the wild – a life of ever-changing contrasts but, at the end of the day, a life of appreciation for the wildlife with whom we share our planet.

A different view of an elephant herd drinking, taken lying down in the water, which I checked for snap-happy crocs beforehand. I deliberately shot this with a long lens to compress the trunks together in the frame and to minimize disturbance to the elephants [Canon EOS-1v, 500mm f/4L IS lens, Velvia, f/11 at 1/90sec]

January is a very grim time to be in the UK. It rains – a lot – and the skies are solid grey and murky – a lot. Travelwise my options are limited; much of the Arctic is still in 24-hour darkness, Antarctica is only for those with bundles of cash to spare, and in Africa the rains are falling. India, on the other hand, is warm and welcoming, and it offers my two favourite pleasures in life: tigers and curry.

January

Into the tigers' domain

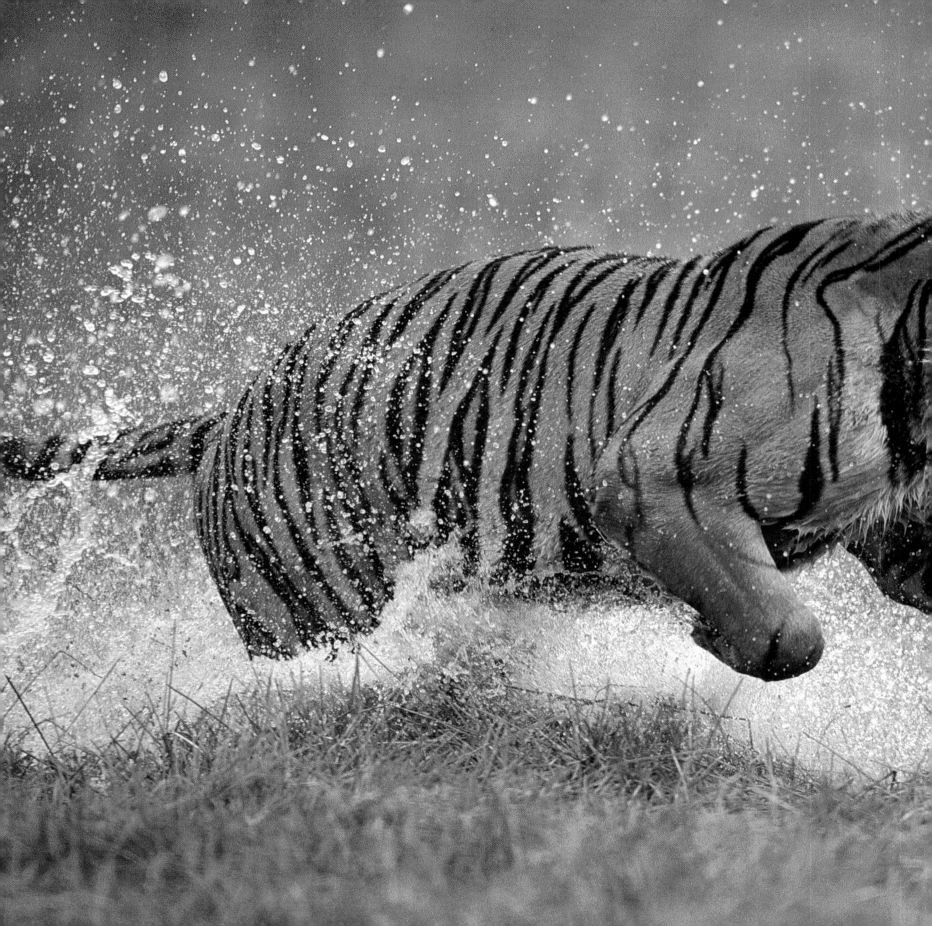

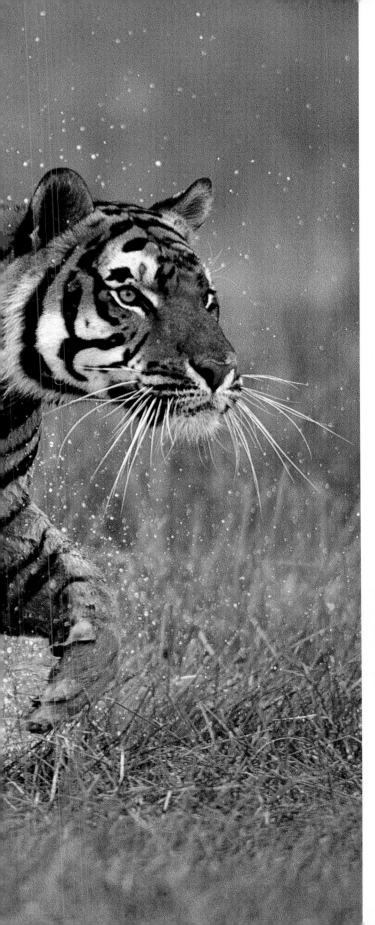

I had only seconds to get this powerful image of a tiger exploding through the water [Canon EOS-1v, 500mm f/4L IS lens, Provia 100F with 81A filter, f/4 at 1/500sec]

Planning

Something deep inside draws me to tigers. I can vividly remember the first time I saw one; it was striding majestically through the undergrowth, then stopped and fixed its gaze on me. I felt its eyes go right through mine, looking not at but through me as though I were not there. When I looked deeper into its eyes I saw a fire of wild intelligence, a look of freedom that people have long since lost.

For about a year I heard talk of an excellent tiger guide who worked in Bandhavgarh National Park in India. I have been told about many 'excellent' guides, most of whom turn out to be useless when it comes to the crunch, but this guide, Nanda Rana, was recommended by *National Geographic*. I need guides who are local experts, willing to take risks with life and limb and keen to work demanding hours. After talking to Nanda on the telephone for just five minutes, I realized that he was someone special. At that

Another high-action image; this time I locked directly onto the tiger's eyes as I knew they would be the main focus of the shot [Canon EOS-1v, 500mm f/4L IS lens, Provia 100F with 81A filter, f/4 at 1/500sec]

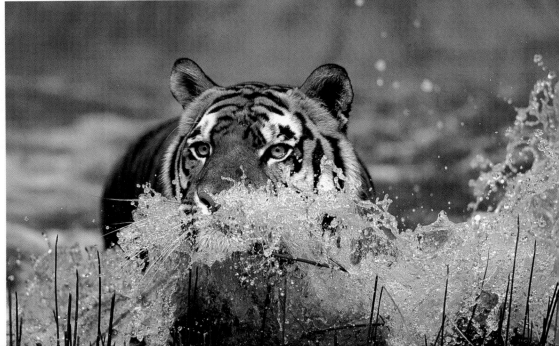

time I did not know that he was a member of the royal Rana family who had ruled Nepal for 104 years. One thing that was clear was that Nanda knew more about the tigers at Bandhavgarh than the tigers did themselves.

Months of planning followed, and several times my finances caused the trip to be postponed, but finally my travel day arrived.

Air travel

I don't like airports one bit as the hassle of travelling with expensive camera gear can ruin the start of any trip. After heaving my baggage through the airport check-in (see the panel, Packing your kit, on p 20), I was faced with the dreaded X-ray machine. At most airports there are signs that state 'this machine is film safe'.

This is true for the newer X-ray machines, but in parts of India and Africa there are machines still in operation that Florence Nightingale would be proud of. Here are my ploys for getting film, and private body parts, through untouched.

At major airports I allow my film five to six passes through a normal X-ray machine before worrying. After that – or in places where they crank-start the machine – I ask for a hand search.

▼ I am always very polite when asking for a hand search, as the security officials are there for my safety and are busy people. I make myself a lot more popular by keeping the film in clear plastic canisters (like those supplied by Fuji film) and having the whole lot in film bags through which the films can be easily viewed. I never use X-ray-proof lead bags as they arouse suspicion and will always result in a search.

▼ If a hand search is refused then I put the film through the X-ray, no argument. I have had film go through 12 to 13 X-rays with no damage, but of course I prefer not to take the risk.

▼ I never put my film into the hold baggage, as the X-rays used to check this are very powerful and will certainly affect the film.

The final stage of the whole process is actually getting onto the plane. Typically, this day I was flying through Paris Charles de Gaulle, where the staff are trained to be as unhelpful as possible. In the end I pretended not to speak English and spoke to the cabin staff in broken Norwegian. After a few minutes of pointing and smiling they gave up and let me on board; the only problem was that I then had to pretend, for 10 hours, to be from Norway!

Arriving at Delhi airport, I was immediately questioned about all my camera gear. Fortunately, I had acquired a journalist visa for the trip and had the proper documents from the National Parks office. For the photographic tourist this is unnecessary but for a professional who requires 'behind the scenes' access, it is becoming the norm. Dealing with the bureaucracy of getting them over the previous few months had nearly caused me heart failure but they were now coming into their own. The officials were friendly, courteous and knowledgeable about photography. I smiled as they told me all about their family photographs, but eventually found an escape route.

Nanda was outside to meet me, and a few hours later we were on the train to Bandhavgarh, a journey of some 18 hours. We had a small, second-class sleeper compartment of four beds. This we duly filled with all our baggage which we chained to the beds for security. India is not a violent country, in fact it's the opposite, but like

February

Winter in Wiltshire

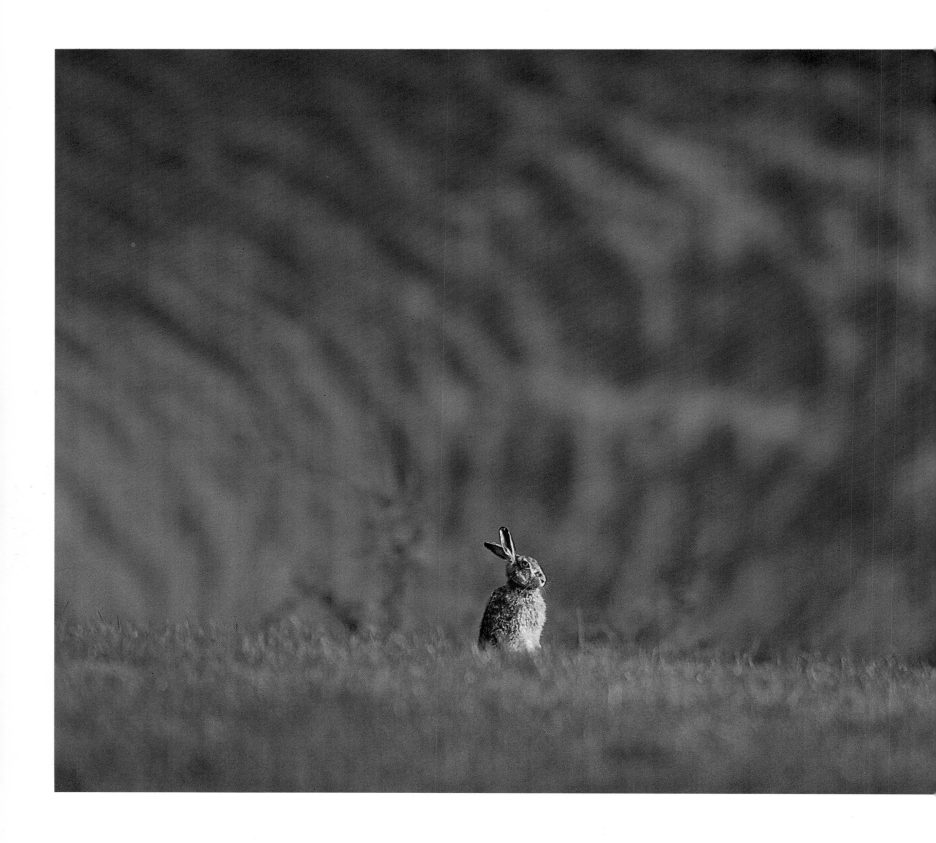

Hares

I usually spend February catching up with work in the office and planning for the year ahead. This particular February I had lots to do, with the new tigers to get ready for clients and deadlines for several trips looming. Amongst it all I found time to struggle out of the office and into the field to pay a visit to my local friends.

This is the month I start photographing one of my favourite mammals, the hare, though in truth much of the work is preparation for their courtship in April. I embarked on a steep learning curve about hares several years ago. For the first few months I succeeded only in getting their backsides as they ran away. Then, in the summer, a local gamekeeper (a vital contact) told me that he had regularly seen several hares feeding on a kale crop. My photography often works in this way; I get a tip-off, then the rest is up to me. So, in the middle of the day, when the hares would be snoring merrily away, I went to check out the site.

When visiting a new place my first question is always 'Can I sneak up without causing the animals any stress or disturbance?' This site offered plenty of

Hares are very inquisitive; this little chap came bounding up to my vehicle when I stopped across the field from it [Canon EOS-1v, 500mm f/4L IS lens, Velvia, f/8 at 1/90sec]

At first I thought this was a very straight shot but, through the lens, the downland topography behind the hare makes it a little more interesting [Canon EOS-1v, 500mm f/4L IS lens with 1.4× teleconverter, Velvia, f/11 at 1/60sec]

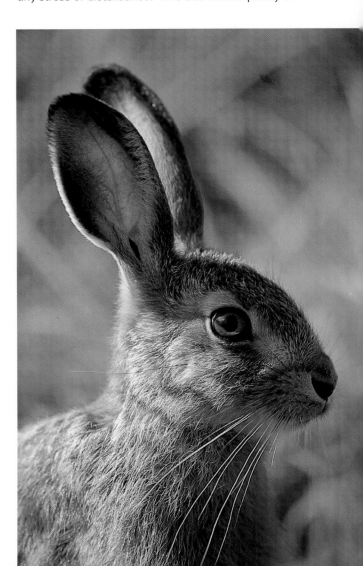

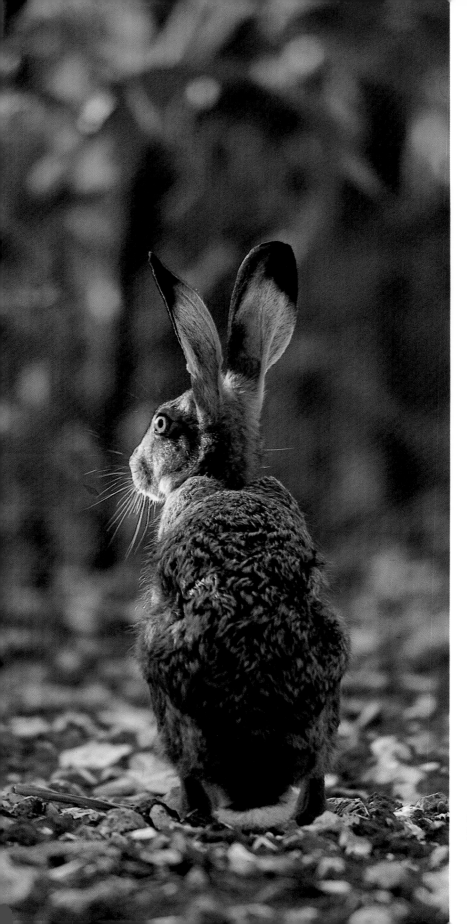

cover for my approach and several options for the hide. To minimize stress to the wildlife, I never move a hide once it is built, so I spent an hour figuring out the best place for it. I knew that the hares would shelter in the cool maize during the day, venturing out to feed only late in the afternoon. Using a compass I figured out where the setting sun would shine, examined the ground for the greatest density of fresh tracks, then decided to build my hide in a hedgerow. I opted for a RealTree hide (see panel on p 30) to blend in with the surroundings, quickly set it up, covered the front with branches, and hacked out a path into the rear so that my access would not disturb any exceptionally hungry hares that were out early, feeding. The hide gave me a great view of the crop. As the kale was growing taller, time was of the essence and I could not afford to leave the hide for a few weeks, as I would have liked. Two days later, struggling under the weight of my 600mm lens, heavy tripod and corned beef sandwiches, I made my first visit.

I set up the gear inside the hide quickly and quietly, arranged spare films on the floor, then sat and waited silently. Kale korma or sweet-and-sour kale fail to whet my appetite but for the hares it was gourmet heaven. As the sun lowered they began to emerge from the maize. I took a few pictures of one chap some 100m (330ft) distant. A movement off to the left caught my eye – a hare had emerged from the maize right next to my hide. My lens was pointing in the opposite direction so

For me this says it all about hares, ever watchful and alert, able to blend in with the background, and a nightmare to get close to [Canon EOS-1v, 500mm f/4L IS lens, Velvia, f/5.6 at 1/30sec]

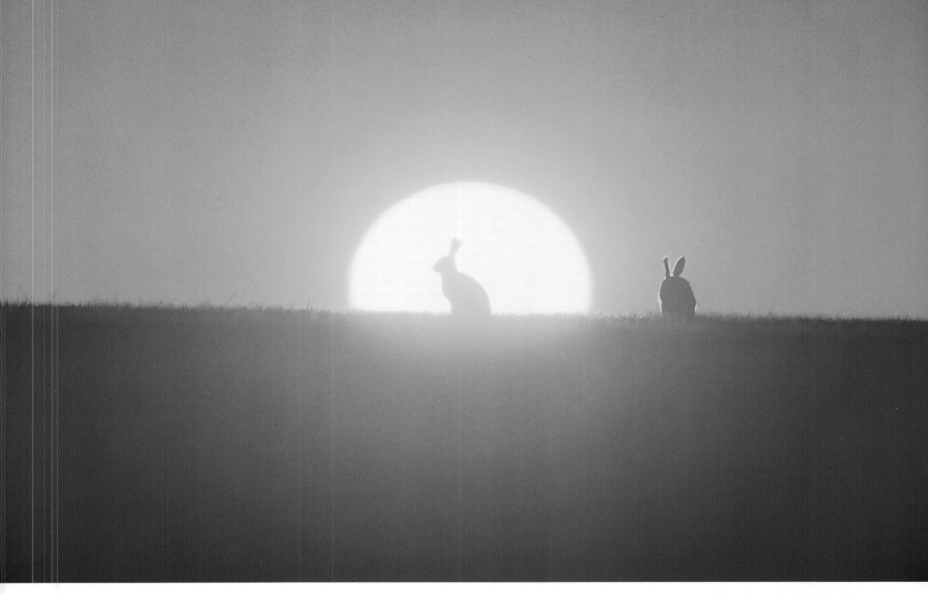

I painstakingly moved it, notch by notch, stopping whenever the hare stared in my general direction. After a few minutes work, throughout which I sweated more than during a tax inspection, the hare finally appeared in my viewfinder. In the next minute or so I managed to take the best-selling hare shot in my collection. I was able to do this because I respected my subject; if I had swung my lens around faster, the hare would have been scared, run off, and avoided the hide for all time.

One minute of success

The start of the day was pretty grim, a typical February overcast grey, but as evening approached the clouds parted and the sun peered out. I love filming in soft winter sunshine, so I had no hesitation in getting out to my local hares. I edged my Jeep slowly across the fields, one hand on the wheel and the other holding binoculars to my squinting eyes. When working with sneaky or shy animals,

I could not have placed this hare better if I had used Photoshop! But it was a true wild shot – just one of those things that happens when you exercise patience and persistence; shame about the other hare facing away [Canon EOS-1v, 500mm f/4L IS lens, car mount, Velvia, f/4 at 1/500sec]

binoculars are an invaluable tool and I would never be without them (see the panel on p 33).

After a fruitless hour, and with the sun beginning to set, I decided to head for home. Halfway across the field something on the horizon caught my attention. Through the binoculars I saw several sets of ears just poking above the growing crop. Hearing the sound of my Jeep, which is as stealthy as a tank, the ears all stood up and became hares. They created a beautiful silhouette against the red sky. I knew I had only seconds to get the shot.

When the hare stood up and boxed in the middle of the sun I almost cackled out loud but instead sang my victory song – David Bowie's 'I'm A Laughing Gnome'. Hardly a Bowie classic I know, but I always hum it when I know I have taken something exceptional.

Snow pictures

In the south of England, February was performing true to form and, as the month wore on, the skies became greyer and greyer. The sunset hares that I had taken a few weeks earlier came back from processing and lifted my mood for a day or so but the grey skies soon put a lid on that. They then turned even greyer and it started to snow. Where I live this is unusual, and even more so if the snow stays for a few days, which it did. To me this was the signal for frantic activity. I think the best way to show you my controlled panic is in the form of a few days' diary entries.

WEDNESDAY

I always have several sites ticking over just waiting for such an opportunity. First stop was my kingfisher roost, which I had last photographed two years previously. I quickly put one of my RealTree dome hides up (see panel on p 30),

Photographing silhouettes

Fiddling with exposure, metering and focus, especially from the confines of a car, would have lost me precious time. Experience took over and I used several tricks of the trade. I wanted the hare to be a perfect silhouette but knew that metering directly off the hare would be a waste of time, so I did the following, which you can use as a quick rule of thumb for photographing silhouettes.

Using the camera meter, I took a reading from the brightest point of the viewfinder image (not the sun, for obvious reasons). In the same way that the human eye squints when looking at the sun (thus giving a darker picture), the camera is fooled by this into increasing its shutter speed (assuming, of course, that you are in AV mode). Mine leapt from 1/125sec to nearly 1/500sec, giving an image two stops darker. I recomposed the shot, switched the camera to manual mode, dialled in the new reading (1/500sec at f/5.6) and finally, selected manual focus as the autofocus would have a nightmare with the sun. Simple. Well, not at first, but it soon becomes second nature.

close to a favoured perch but hidden by a thorn bush, then left the site alone. As it was snowing ever harder, on the way home, after a stop at the butchers, I put down some food for a fox I had been feeding in my local woods. In the winter foxes need energy, so I always feed them scraps from the local butchers; most butchers are happy to give me scraps free.

Sometimes autofocus is the hero but here it would have been the villain and missed me the shot so I switched to manual focus, just in the nick of time [Canon EOS-1v, 500mm f/4L IS lens, car mount, Velvia, f/4 at 1/500sec]

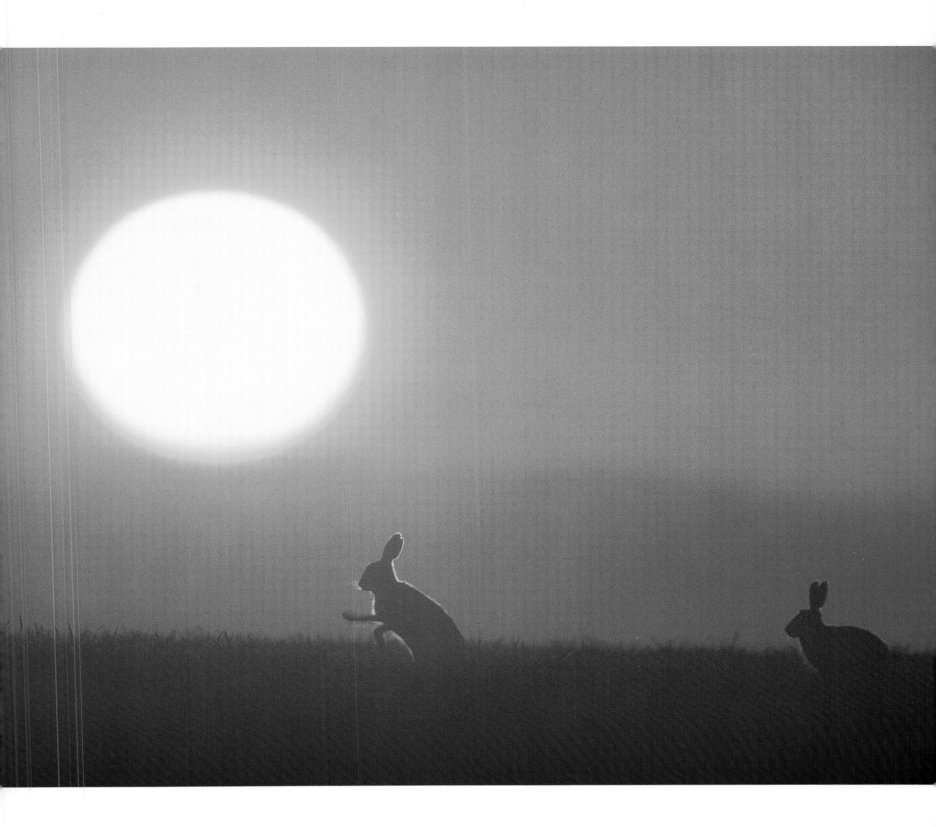

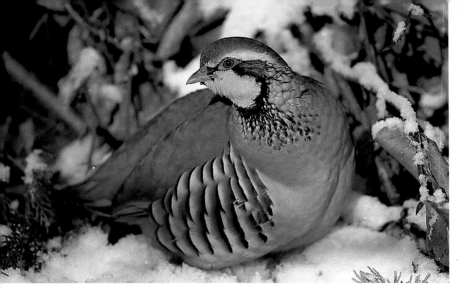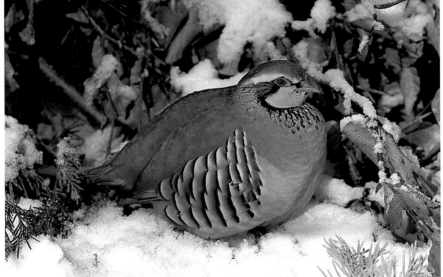

Before emerging from the safety of cover, the partridges would always have a good look around for predators. As a cloth-covered human did not register as a predator they completely ignored me – I only wish there had been a pear tree close by! I deliberately used an aperture of f/8 to ensure that everything was sharp, and used an 81A filter to warm up the winter sunshine further [Canon EOS-1v, 100–400mm f/5.6 IS lens, Velvia, f/8 at 1/60sec]

Dome and bag hides

I use hides, both domed and bag, to mask me from the view of animals with good eyesight, to avoid causing stress to animals that are easily disturbed, or to keep my scent from animals that have a keen sense of smell.

A domed hide is really a camouflaged tent. They are available in many different colours, to match the background in which you are working. They are quick to erect, spacious, waterproof, and provide total cover from prying eyes. Domed hides are much more effective than box hides as their shape is more natural.

Bag hides are basically large pieces of camouflage material shaped to cover a human, with a slot in the front to fit a lens through. I generally use them to break up the shape of my body when I am stalking; I rarely clamber inside one.

THURSDAY

The snow settled nicely so I turned my attention to the red-legged partridges on my local sporting estate. The estate feeds them all through the winter and I knew the secret to success was to lurk close to a feeder in the late afternoon. There is no great science in this; I asked the gamekeeper when he fed the partridges and he told me they were always fed after lunch. A normal hide would frighten the partridges, as there was little cover to camouflage it, so I had no choice but to flatten myself into the ground and use a camouflage-bag hide (see panel).

I chose a spot which would ensure that the sun set behind me, not only for the good light but also to make me difficult to see, and waited. Partridges came to the feeders and left while my privates froze more solidly to the ground. Trying to ignore the feeling (or lack of it), I concentrated on getting everything nicely in focus and well exposed.

I finally crawled away, defrosted myself, and drove to the fox site. I smiled at the fresh footprints and put some more food down for old Charlie. Tomorrow he would be mine.

FRIDAY

I had been preparing this fox site for months and had hollowed out a log pile for my hide. Foxes are very smart and to fool them, a hide needs to be perfect. I arrived early in the morning, moulded myself into the hide and waited patiently. The local blackbirds announced the fox's presence; along the path he trotted, stopping only at the fresh food that I had put down. I waited until he had started feeding before taking my first picture. In the still winter air it sounded like a rifle shot and the fox looked up, straight at the log pile. I froze, breathing into my coat to keep any traces of my breath inside. This was a perfect fox shot, but I decided that to take another picture would reveal my presence and scare him off. Finally, he licked his lips and trotted off without a backward glance. It was the perfect encounter; I had not scared him and he got some much-needed food from it – foxes have a hard time hunting in bad weather. However, my picture was awful and I am not going to give you a laugh by showing it here. I had done my best but not everything goes to plan.

SATURDAY

Bad light stopped play as the day was very grim and cloudy but also, alarmingly, warm enough to start melting the snow. By the afternoon most of it was gone. The weatherman predicted an overnight frost though, so I knew that tomorrow would be my last chance to capture the kingfisher in a wintry scene.

SUNDAY

I was in the hide before sunrise and didn't have to wait long for the shrill peeping that announced the kingfisher's arrival. Obviously a creature of habit, it perched exactly where I had photographed it two years before! The overnight frost created a wonderful effect which I knew would vanish soon after the warming rays of the sun appeared.

There is a limit to how many poses you can take of the same bird in the same location. Eventually, around lunch time, the kingfisher flew off. I collapsed the hide and retreated quickly to the warmth of the car. I would be back for the breeding season in a few months but for now I would leave them well alone.

As all traces of the snow finally disappeared, I was happy that I had given it my best shot. I knew that both the fox and kingfisher sites would be used again in late spring/early summer, but that was a long time ahead.

The next three months would be the busiest of the year for me as I would be travelling almost constantly, with only the occasional break at home to replenish my film stocks and catch up on my favourite soap-operas or TV shows.

Wideangle style

I am a frustrated landscape photographer at heart and love to include landscapes in my wildlife images. I decided that the best shot of the kingfisher was not a tight portrait but a wideangle with the main emphasis on the frosty bush. To reduce the chance of camera shake, I used a remote cord to trigger the camera and locked the mirror up using the camera's custom functions.

A well-used badger and deer track made visible by the snow [Canon EOS-1v, 28–80mm f/2.8L lens, Provia 100F, f/11 at 1/125sec]

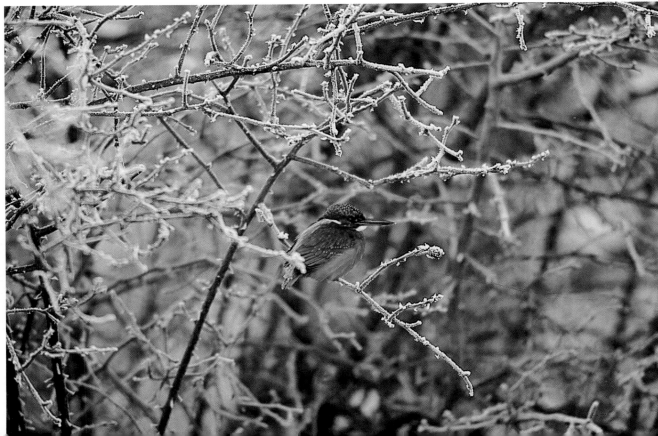

Quite a wideangle shot, this works due to the beauty of the frost-laden tree [Canon EOS-1v, 600mm f/4L lens, Velvia, f/8 at 1/30sec]

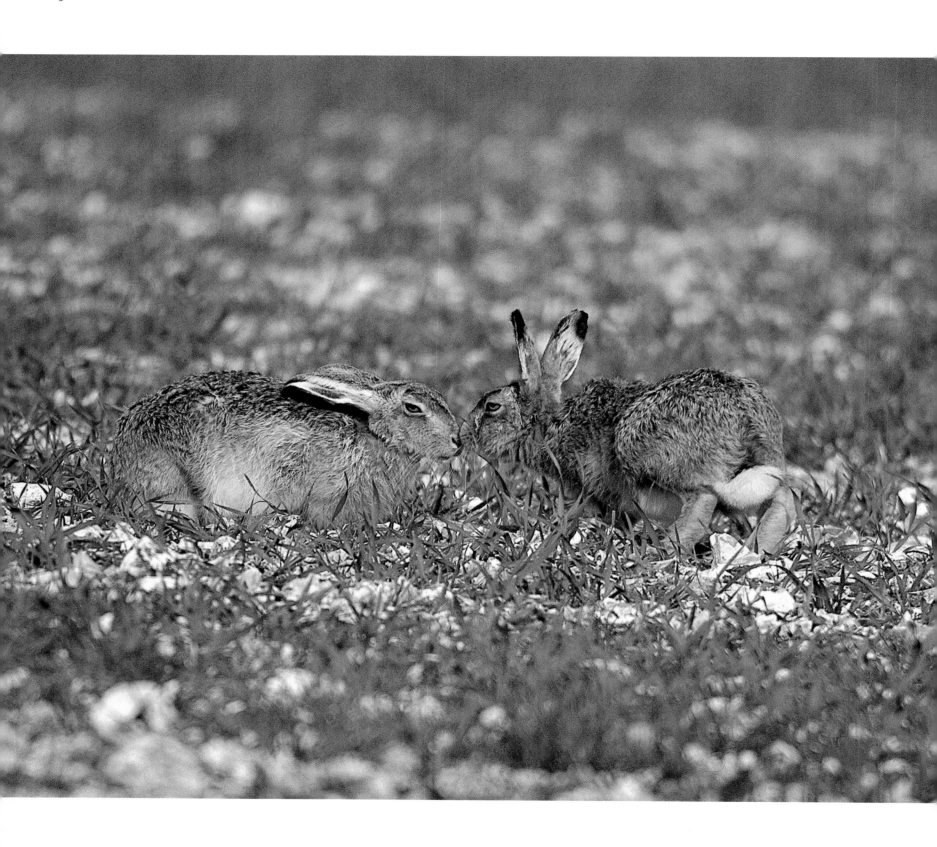

Gear box

- Canon EOS-1v bodies with NiMH drives × 2
- Canon 500mm, f/4L image stabilizer lens
- Canon 600mm, f/4L lens
- Canon 100–400mm f/5.6 image stabilizer lens
- Canon 1.4× teleconverter
- RealTree dome and bag hides

As I was spending February in the UK and didn't have to pack, I could use a great selection of my 'normal' camera gear. One thing that I have learnt, however, is that I need to decide what equipment I am going to use in advance, as it is impossible to drag all my gear round with me these days. With subjects such as hares it is easy – I know that they will be away in the distance, so it is a simple matter of picking my longest lens.

This month I used two types of hide – a rigid, domed hide and a RealTree bag hide. I find the latter very useful day to day, mainly for covering up the white lens barrel when I am trying to lurk without being seen!

Binoculars

Binoculars are often associated with those who possess an anorak and indulge in the habit of weekend bird-watching. This is unfair press as they are an essential tool for any wildlife photographer.

Unfortunately, our eyes never come with a built-in zoom capability like the Six Million Dollar Man (1970's television series, bionic man, dodgy music and effects); we can see things in the distance but can't resolve them into clear shapes until we get a lot closer. This is fine for most things, but when dealing with wildlife it generally means that 'the thing' moves faster in the opposite direction and disappears.

Benefits

Binoculars help you to:

- ▼ scan areas of habitat for lurking subjects
- ▼ observe animals from a distance without being seen
- ▼ avoid unnecessary disturbance to shy animals
- ▼ watch and enjoy animals long after the light levels required for photography have been lost
- ▼ watch the neighbours when they have a Roman toga barbecue

So you find out there's a party next door in a few days and you need to get a pair of binoculars. What do you look for? Well, the binocular world is full of confusing jargon; here is my translation.

Numbers

When you see the specification for a pair of binoculars, it will usually give two numbers, for example '10 × 50'. The first number, in this case 10, refers to the magnification, or power, of the binoculars. A magnification of 10 would make an object 100m (330ft) away appear 10m (30ft) away, that is, it would appear 10 times closer. The second number refers to the diameter of the lens, and the larger the diameter, the brighter the image will appear. In the same way that an f/2.8 lens lets in more light than an f/5.6 lens, a 10 × 50 pair of binoculars will let in more light, and therefore give a brighter image, than a 10 × 40 pair. What is the best combination? Although the clearest and most powerful specification for binoculars is 16 × 50, in practice, they would be heavy and cumbersome. I would always opt for 10 × 42, which are light, have a good optical range, and good light-gathering capabilities.

Construction

My binoculars lead a hard life; they get thrown around, stuffed into pockets that are already filled with dead animals, and subjected to rain and mud on a regular basis. It is vital that you buy a pair of binoculars suitable for the job you intend them to do. For wildlife photography, get binoculars that have a bounce-proof rubber casing.

Price

My final words on the subject are, be prepared to pay for quality; the more you pay the better the product you get. I use 10 × 42 Swarovski binoculars which are expensive but worth every penny.

An intimate shot; the male is checking the female's scent to see if she is in season. Two seconds later she answered him with a whack on the nose! [Canon EOS-1v, 500mm F4L lens with 1.4× teleconverter, Velvia, f/8 at 1/250sec]

March is a transition time for wildlife; the harsh realities of winter reluctantly give way to the warm promise of summer skies. In the polar north, above the Arctic Circle, winter finally eases its icy grip and the sun's warming rays appear over the horizon for the first time in months. It's the signal for life to begin again, and for me to pack my thermal undies and head north. I'm going to the realm of the largest land predator on earth – the mighty polar bear.

Travels with pisugtook

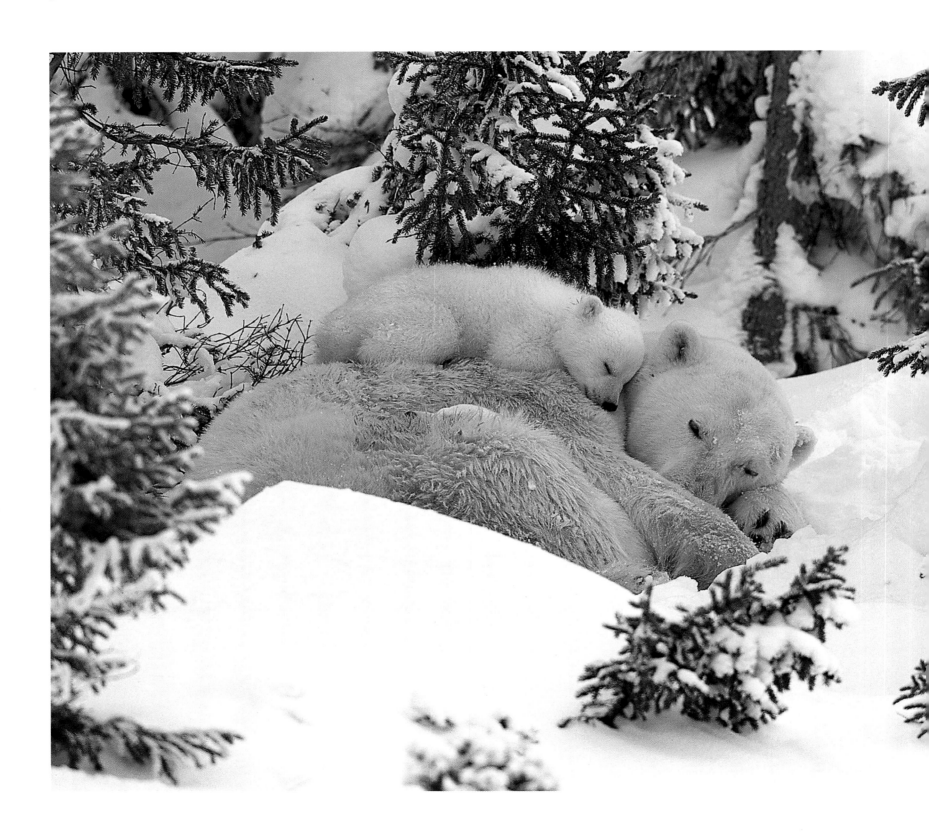

Arctic journeys

The polar bear is the great Arctic traveller, a nomad that carries its territory wherever it goes and calls nowhere home. The Eskimo name for the polar bear is pisugtook, which means great wanderer, and there is surely no truer name in the animal kingdom.

Polar bears were brought into my life by the BBC film *Kingdom of the Ice Bear* which was filmed on Svalbard. I watched, fascinated, as the young cubs struggled out of the den into the harsh environment for their first glimpse of the world. Since then I've been to Svalbard many times and not a day has passed when I haven't looked up to the towering, ice-capped mountains and dreamt of seeing young cubs staring back at me. Unfortunately, the last time I did this, I was so busy looking for cubs that I failed to notice a nasty lump of ice in my path. Seconds later I was underneath the snowmobile with a laughing guide standing over me taking bribes to haul me out.

Joking aside, I knew that although I had a huge collection of photos showing wonderful polar bear behaviour (courtship, hunting) and landscapes, there was a gaping hole – mothers with cubs. Wildlife photography is an incredibly competitive business and the key to success is to be able to give a client what they want every time you are asked. So I knew that to keep the bank manager from writing nasty letters to me, which he seems to get a perverse pleasure from, I had to get these shots.

Cute, commercial and an absolute privilege to share. As the scene was mostly white, I used my Sekonic handheld meter and set an aperture of f/8 to make sure everything was in sharp focus [Canon EOS-1v, 500mm f/4L IS lens, Velvia, f/8 at 1/60sec, handheld meter]

I composed this sleeping bear off-centre to bring in the beautiful iceberg [Canon EOS-1v, 500mm f/4L IS lens, Velvia, f/8 at 1/60sec]

The problem was how? The denning areas on Svalbard are so remote, it would cost tens of thousands of pounds to get there and set up and there was a good chance that I would luck out. One financial mistake and I'm out of business; this would be a little unfortunate as now my only career alternative would be strawberry picking.

As my India trip demonstrated, good research is one of the keys to being a successful wildlife photographer. Last year I knocked on every door of every polar research project I could find in the hope of tagging along. Every door closed on me, some slammed hard. I was beginning to give up hope of getting the money legally and considered selling my body for art's sake but quickly gave up that idea as it would take a lifetime to save anything at the rate I'd get. A phone call out of the blue changed my luck; a group of professionals were putting together a unique trip to a denning area. I snapped up one place for me and one for Tracey who was going to film the whole experience for a future series of *Wildlife Photographer* (a TV series broadcast internationally). We were off!

After all the travel hassle of my India trip, I finally decided to play the press card. Airlines usually fall over themselves to keep members of the press happy (in case they publish disparaging remarks about the in-flight service). As Air Canada offered the best flight price, I spoke to their press office and they kindly put a note into my booking explaining that my nickname was 'violent axe murderer of check-in staff'. It certainly did the trick as Tracey and I boarded the plane with no trouble at all. It took two days of travel – involving planes, trains and a dodgy transit van on skis – to arrive at our remote cabin, and we did so minus all our hold baggage which had been left behind in Canada. Fortunately, as this has happened to me many times before, I was prepared and had carried enough camera gear to shoot with in my hand baggage. Shame about the clothes; we would just have to be a bit chilly for a few days.

First encounter

I stepped out of our cabin into a −25°C (−13°F) freezer and quickly loaded our gear into the bombardier (a vehicle specially adapted for use in the Arctic). Our guides, locals, sped off ahead on their snowmobiles. They would be our eyes whilst we bumped along behind. After a few hours' tundra-watching, we saw our guides parked ahead, staring intently through binoculars at a small hillside some 10m (30ft) high. I jumped out and tentatively asked one of our guides what they had seen. He peered at me from inside his fur-lined hood, revealing a tough, frost-covered face, before pointing to the hill and saying, 'den with mother inside'. His words hung in the air for seconds before I realized what they meant. This was it. We had found an active polar bear den. Yesssssssssssssssssss! Telling myself to calm down, I quietly went about getting ready.

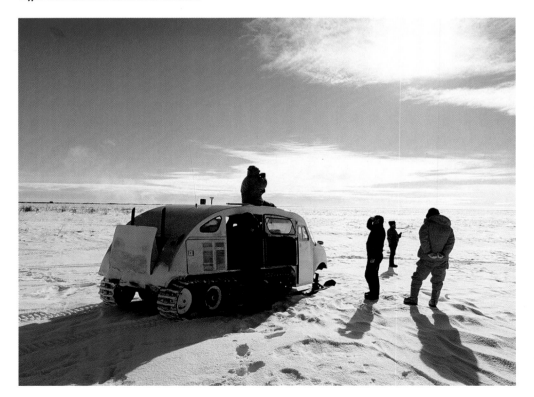

Here we are out on the ice checking for signs of polar bears, although the chap on the top is certain he can see the Eiffel Tower. It must have been the cold.

A slight movement in the darkness at the back of the hole caught my attention. I looked through the lens and took a sharp breath, for staring back at me was a very inquisitive female polar bear. She blinked in the evening sun, which was now so low that it cast a beautiful red glow on her fur. The sun idly sank until, finally, it sat on the horizon. This acted as a trigger for the mother to disappear inside the blackness once again. I was just about to pack up when two tiny eyes peered at me out of the gloom.

The cub was absolutely the most adorable bundle of fur that I had ever seen. We stared at each other for several seconds before the protective mother intervened and called her offspring back into the den. Tomorrow would be another day of great opportunities; I only hoped I would be good enough to capture them. Little did I know how good it would turn out to be...

Problems with light and stability

Normally my tripod would have been the first thing I packed, but it was still wandering around Canada trying to find us, so I improvised and packed my rucksack solid with spare clothes so that I could balance my lens on it. It wasn't perfect but, using my image stabilizer lens, I would have at least a slight chance of getting something good. Next I checked the light. In situations like this, where there are no reference points other than different shades of white, the camera meter can't be relied upon, so I used my 100% reliable handheld light meter.

Proof that I practise what I preach; supporting a lens on a Lowepro bag stuffed with my undies [Taken by Tracey Rich]

The moment I had dreamt of – a female polar bear looking out from her den with her cubs tucked in safely behind

Teleconverters

The light meter read 1/30sec at f/4 with Provia 100F loaded. To get a higher shutter speed I pushed it to ISO 200, which gave me 1/60sec at f/4. This meant I could just about shoot with the 500mm lens. Unfortunately, I really needed to be in closer, but walking towards the mother would have caused her stress and may have provoked an attack. I was forced to put on my least favourite accessory – a 2× teleconverter. I use 1.4× teleconverters all the time with great results, but the 2× versions are dark and gloomy cousins. The worst factor in using them is the two-stop light loss, which in this case reduced my already gloomy light to 1/15sec at f/4. Still, it was such a beautiful shot, I had to try. And all this balancing on a rucksack stuffed with underpants!

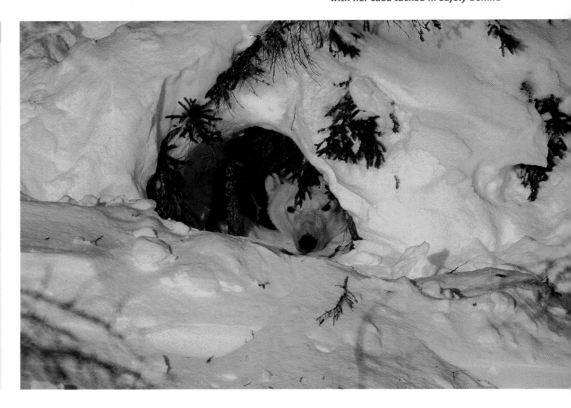

Intimate moments

The mother moved her family from the den under the cover of darkness. By the time our snowmobile scouts found them they had covered a surprising distance, but eventually we reached them. The bombardier lurched to a stop and I clambered out eagerly onto the fresh ice. I slipped straight onto my backside but it was a good slip and the judges gave me 9.9 for artistic merit. I picked myself up, ignored the laughter, and watched the mother watching us from several hundred metres away. This was a lovely 'bear on tundra' shot, so I set up

my gear. Through the viewfinder I could see her moving her mouth. A gasp from Tracey alerted me to the reason for her concern; a tiny white bundle of fur was trying gamely to catch her up. As the second cub appeared, my commercial head took control and I began to record the whole sequence.

The mother waited patiently for the cubs to catch up, encouraging them when the little darlings slipped or fell down some hidden hole. When they finally reached the safety of her huge body, she greeted them with a tenderness that I had never seen in a

The low snowfall meant that many small branches were exposed, which caused my autofocus to misbehave badly. I switched point to lock onto the centre of the mother, using an aperture of f/8 to make sure that the cub was in focus too [Canon EOS-1v, 500mm f/4L IS lens, Velvia, f/8 at 1/125sec]

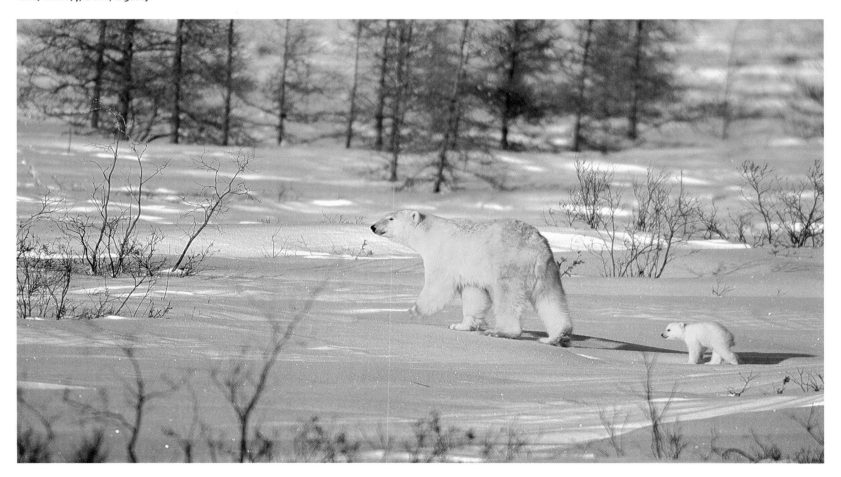

polar bear. After a final glance in our direction, she headed slowly into an island of trees. We knew the cubs would soon need a rest, so we approached slowly in the bombardier, taking a wide arc so that the mother would not feel threatened. We walked the final few 100m (330ft) into the trees, stumbling on the hidden roots but never uttering a word. As I reached the ridge, my eyes widened in disbelief. On the other side, not 50m (160ft) away, was a vision of polar beauty. Sitting in a copse of fir trees, the mother was happily cleaning her two sleeping cubs who were sprawled on her body. The setting was amazing. Our concern was to minimize any chance of stressing the bears, so we spread out slowly and each chose a tree to sit behind. She raised a glance in our direction, but we had never threatened her and she knew it. Animals just know. I don't know how, but they do.

The sun decided to show its face, which of course changed the feel and mood of the scene completely. Gone was the softness and blanket-like feel of the snow – it was now a vibrant blue, sparkling and alive. The bears changed their

Composition

My framing options were limited so I chose to put the mother in the left of the viewfinder and compose the shot so that the cub would walk in from the right. I set the camera to f/8 to make sure that I had enough depth of field to correct for any autofocus problems at this distance.

My tripod, fresh from its travels, had now decided to join the party and everything else I needed was around my waist; spare film, exposed classics and chocolate bars to maintain my spare tyre.

Keeping batteries warm

I could not afford to mess this up so I took my time to make sure I got everything right. My first task was to change the batteries as, in extremely cold conditions, the life of batteries is considerably shortened. I use lithium AAs in my cameras as they have a much longer life than any equivalent. Before setting out, I had loaded several spare battery holders with fresh AAs. When one set froze I replaced it with a fresh set that was ready loaded and toasty warm thanks to a pocket full of chemical warming pads (available from any outdoor store). Most photographers make the mistake of thinking that frozen batteries are dead when in fact all they need is a little warmth and tenderness.

Batteries, chemical warming pads or any form of litter do not belong in the Arctic. They pollute and destroy, so I always ensure that everything I take out, I bring back.

A very cold and ridiculously dressed photographer after several hours of waiting for a polar bear to wake up! [Taken by Tracey Rich]

position to get more of the warming rays and the mother sat down in a spot perfectly framed by the surrounding trees. For the next few wonderful hours with the family, I watched every yawn, laughed at every antic and kept pinching myself to make sure it was real.

When the sun finally set, a team of guides came and chiselled us out of the ice we had been in for the last seven hours. It had been a long, cold wait and changing film became increasingly difficult as our hands turned into claws. But the wait had been worth it, for we had been truly privileged. It was now time to leave the family to the Arctic night; tomorrow we would see if they would keep us company again. Back at the lodge the atmosphere was ebullient and I happily tucked into my roast dinner, safe in the knowledge that at last the gap in my files was being well and truly filled.

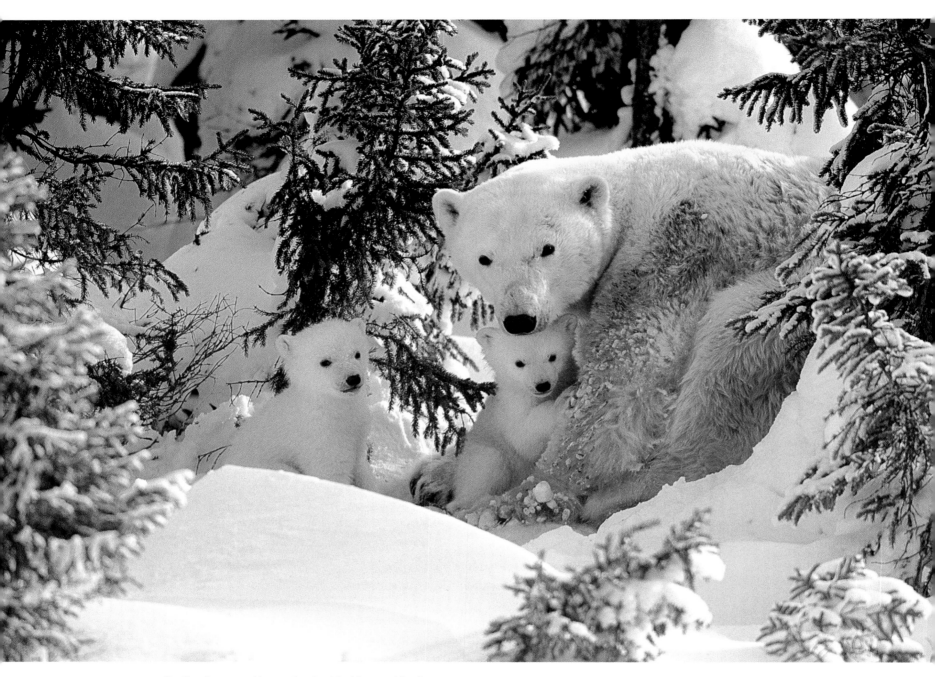

Finally, after several hours, the shot I had been waiting for.
A pretty simple one to take too, as everything is parallel to the
camera, hence I used f/8. The only problem was the metering,
which required plus two-thirds of a stop compensation, and
trying to stop my cheek freezing permanently to the back of
the camera [Canon EOS-1v, 500mm f/4L IS lens, Velvia, f/8 at
1/60sec, metered by guesstimate]

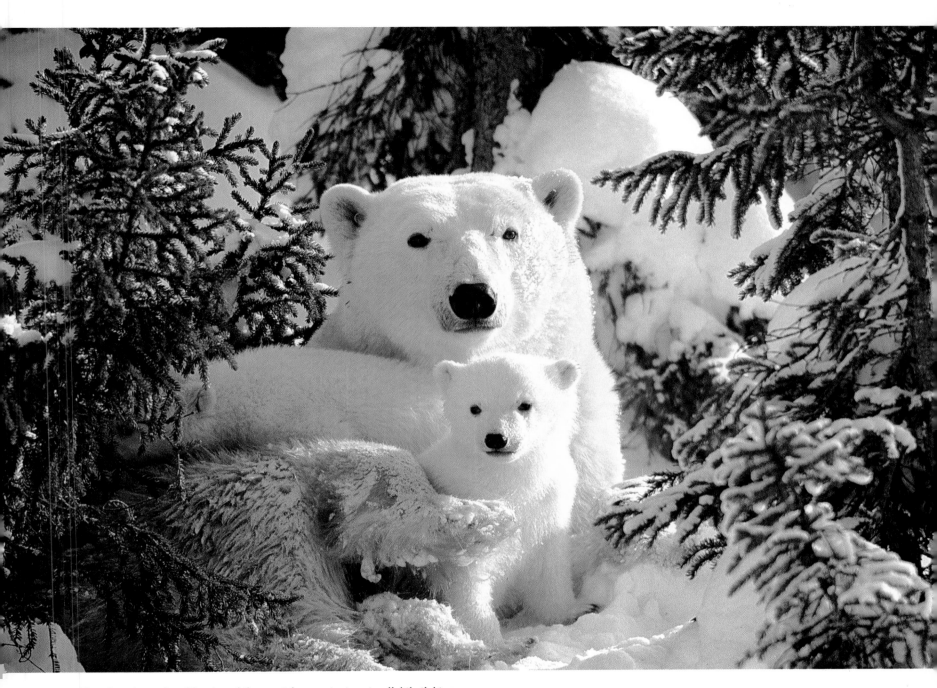

When they changed position, I used the 1.4× teleconverter to get a slightly tighter shot. This time the cub was a little in front of the mother so I decided to use an aperture of f/11 as it would be a crime to spoil such a wonderful opportunity with anything less than a pin-sharp image. By the way, for those of you who can count, the second bear is asleep, unseen, in its mother's embrace [Canon EOS-1v, 500mm f/4L IS lens with 1.4× teleconverter, Velvia, f/11 at 1/60sec – light had improved over previous shot – metered by point and hope]

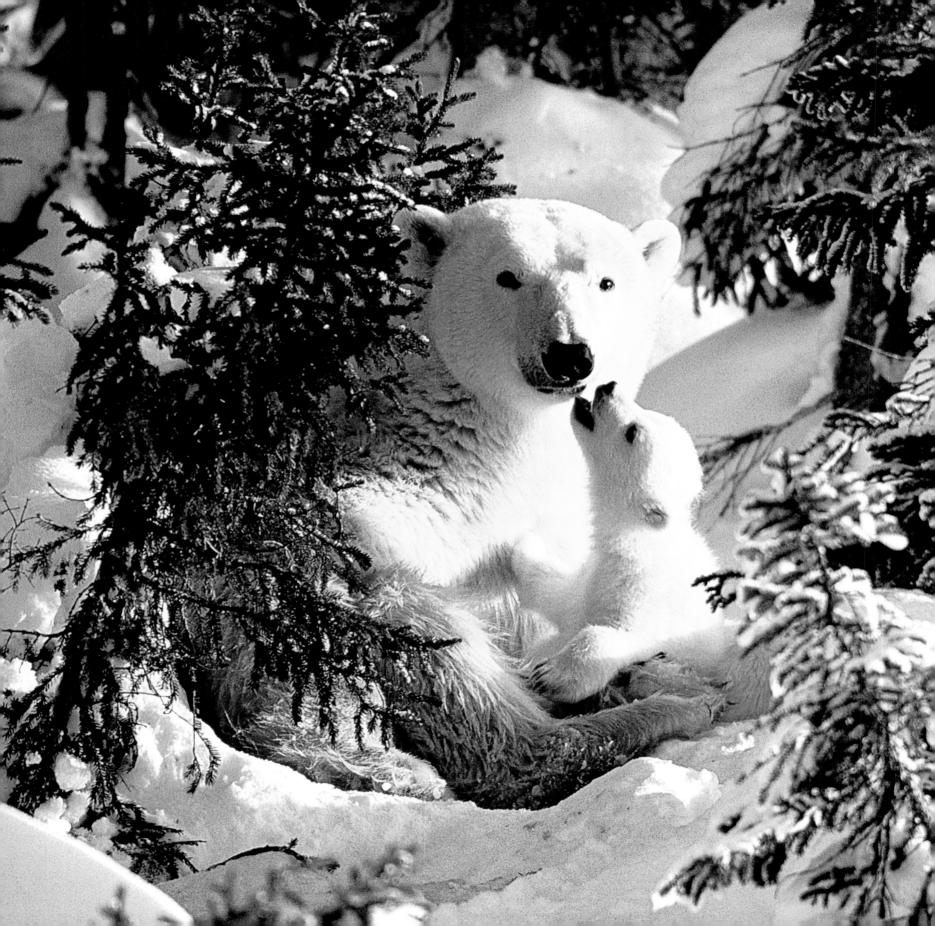

I almost missed this as I was trying to work some life back into one of my hands so that I could change batteries. I noticed that I had only two shots left so timed the moment carefully to make sure that the cub was not only close to the mother's mouth, but also still so as to reduce any blurring [Canon EOS-1v, 500mm f/4L IS lens with 1.4× teleconverter, Velvia, f/8 at 1/125sec, metered via point and hope]

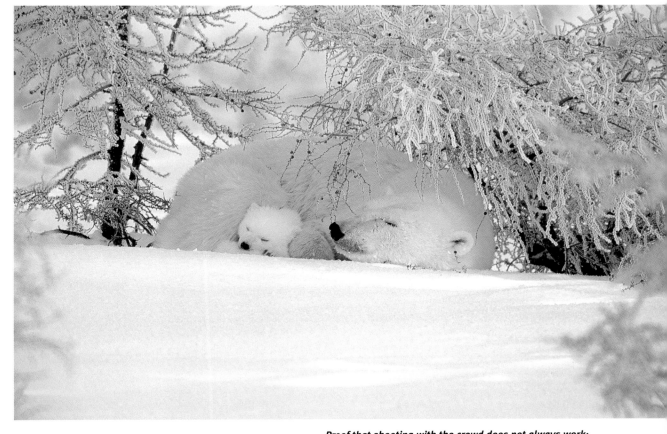

Choice of film

From my exposed position I could get a nice shot of the female lying down under a frost-tinged bush with a cub curled up at her side. It was a beautiful image so I decided to use the fine grain and clarity of Fuji Velvia film to really bring it out. I set the handheld light meter to f/11, grimaced at the low reading of 1/60sec (it was overcast), then set the bracketing to two-thirds of a stop either side. For once I was thankful for the overcast skies: any sun would have ruined the soft feel of the shot.

Proof that shooting with the crowd does not always work; I have seen competitors' shots similar to my others but none like this. I deliberately left some white space at the bottom to lead into the shot, and avoided using the 2× teleconverter to get in closer as it would have spoilt the overall feel [Canon EOS-1v, 500mm f/4L IS lens, Velvia, f/8 at 1/30sec]

Frosty morning

We awoke to a winter wonderland. The night had been cold and a penetrating hoarfrost had developed, leaving all the trees glistening in the morning light. I was outside extra early to prepare my cameras for the day ahead, keeping my fingers crossed in the hope that we would find the family again. Good opportunities are rare; when I get them I never want them to end.

We found the mother's tracks. They led to a single bush in the middle of the tundra, where she was sleeping with her cubs. One was clearly visible with her, the other was buried somewhere in her warm embrace. I watched the other photographers set up their gear and decided to change position. Having a group of the world's top professionals within 3m (10ft) of each other would guarantee a lot of similar, well-exposed shots. To stand out from the crowd I needed something different and with this in mind, carefully moved away from the group.

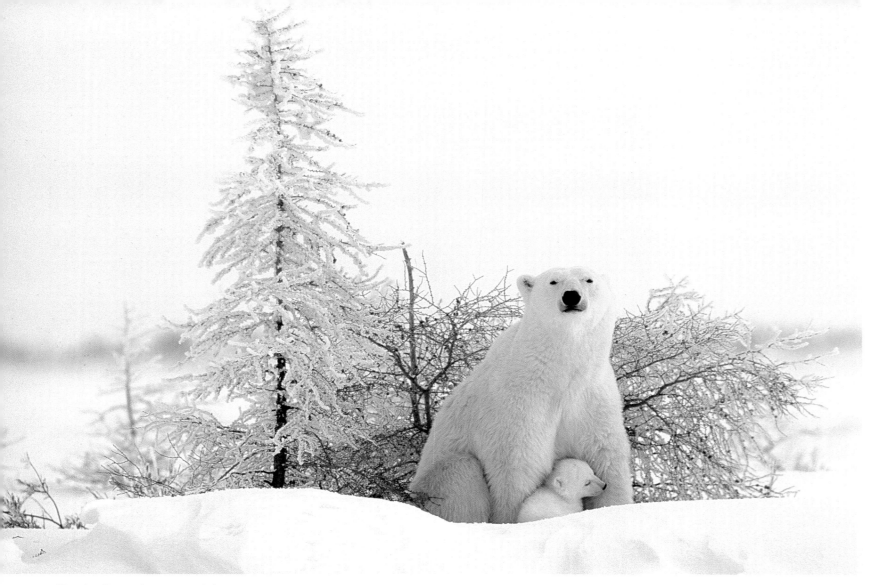

Worrying. Yet another composed shot – an annoying trend creeping into my photography. If I was a black-and-white photographer I would say that the tree gives a sense of isolation in the wilderness but as a Londoner I will tell you, I just thought it looked lovely. At last I could use the handheld meter again so I knew my exposures would be spot on [Canon EOS-1v, 500mm f/4L IS lens, Velvia, f/8 at 1/30sec]

Both cubs were now awake and the female, keen to keep them moving, started off across the tundra. They followed, legs working furiously to keep up, and we decided to leave them alone to their journey. We watched as they slowly made off into the haze.

On the way back we checked out the den that she had left, as Tracey and I were keen to see inside. After an hour of careful digging, the entrance was exposed and we got down to take a look. The entrance tunnel was about 2m (6½ft) long and was a tight squeeze for me. The tunnel, which initially curved downwards, curved up at the

end as it led to a small chamber. The reason for this curvature is to trap the warm air from the bears' bodies inside the chamber, thus keeping out the worst of the winter. If you ever get the chance to see an Eskimo's igloo, you'll notice that the entrance has the same design, proof yet again that we all learn from nature.

Those first days of the trip were special as that particular mother was very tolerant of our approach. In the final few days of our northern adventure, we encountered several more mothers with cubs, and here are a few of our special memories.

Dolphin ballet

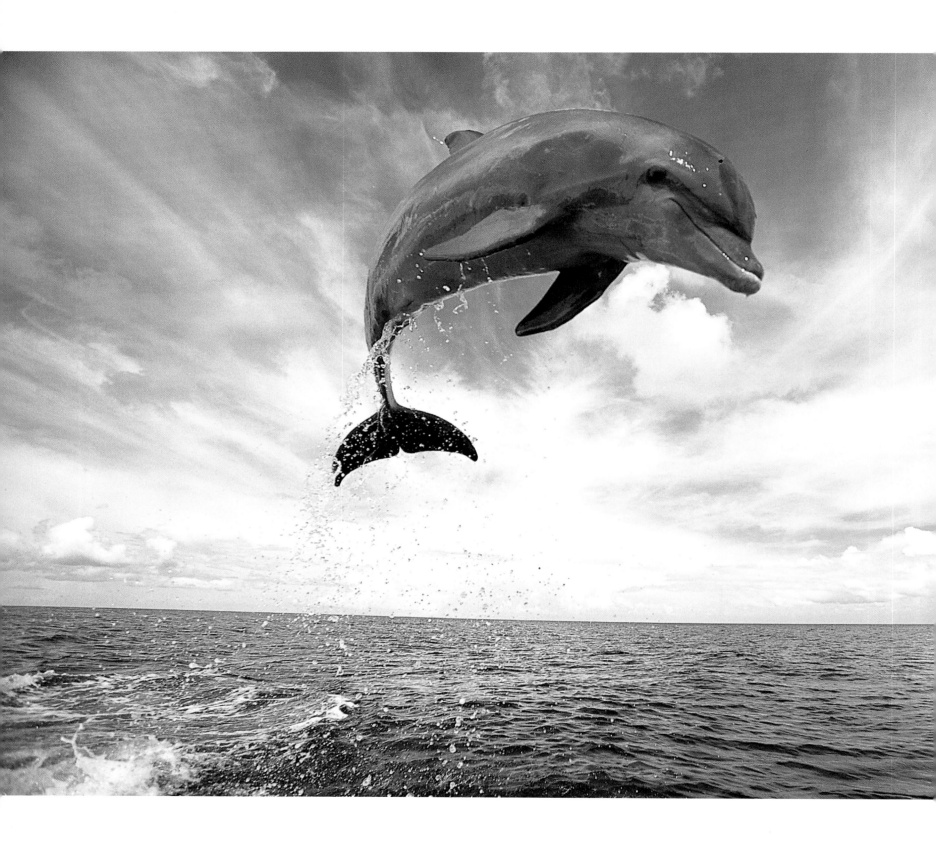

Sudden change of plans

A couple of months earlier I began discussions with a large UK retailer about producing a series of calendars to sell in their stores. Most presented no problem to me and were well into the production stage at the factory in China. Now the client wanted to know if I could shoot a whale and dolphin calendar for next year. 'Great. No problem. Just give me a few weeks to put the images together,' I said, with a wry smile. My smile faded as soon as I put down the phone. I had plenty of whale images in my files but no dolphins – not a single shot of Captain Beaky. In this business friends are everything and one of my best, Brandon Cole, is one of the top marine photographers in the world. He laughed when I told him what I had committed to, then agreed to help. Luckily we had been planning a trip to a dolphin research centre in the Caribbean for later in the year,

now we would just have to bring it forward by several months. I do love challenging myself, it keeps my photography fresh, but this time I had made a lot of promises, which I hoped my ability could live up to.

To the Caribbean

I arrived, wrestled my two bags from the baggage handlers and, together with Brandon, set off for the research centre where we would stay. It was paradise, a scene from a TV commercial. And in this scene they sold cold beer. Next morning we were bobbing around in the calm blue waters of the bay, being greeted enthusiastically by two bottlenose dolphins. It was heaven. This would be an easy job for once. Or so I thought...

Again my trusty 17mm lens came into its own, this time creating the odd cloud formations [Canon EOS-1v, 17–35mm f/2.8L lens, Velvia, f/4 at 1/1000sec]

Combining the polarizer (to see into the water) with a low angle gives this view of paradise [Canon EOS-1v, 17–35mm f/2.8L lens, Velvia, f/16 at 1/60sec]

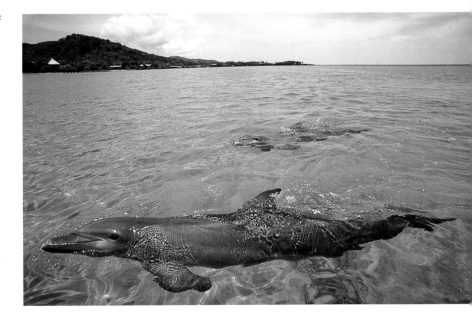

'They are in a playful mood,' said Eldon, the centre's director, 'so get ready.' I needed no second bidding and flung open my case. The boat headed for a patch of shallower water with the dolphins following closely behind.

The dolphins bobbed around expectantly: they knew if they followed the boat they would get fish. As we picked up speed, the dolphins erupted from the water next to me, then landed even closer with a huge splash – the wave hit me a second later. The camera was drenched. I threw it down onto a towel, picked up the spare camera body and carried on. I soon learnt to turn around after each sequence to avoid the splashes and my second camera faired much better than the first. During a lull, I thoroughly dried the wet camera, being careful to take apart the battery compartment and dry that too. These days, most top-of-the-range cameras are designed to be a little waterproof but it pays to be careful as one droplet of water can cause expensive damage.

The dolphins were keen for more fun and games so I changed position and leant right out over the boat. I wanted to get the horizon as low in the picture as possible so that the dolphins would stand out, and the only way to do that was to skim the top of the water. Brandon joined me, causing the boat to lurch alarmingly to one side which brought us even closer to the water. The dolphins thought this was great fun and in between jumps, tried to grab my camera, drenching me further in the process. I began to predict their jumps so that I could get the autofocus locked onto them as they were emerging from the water. By now I was so wet that a towel made little difference; I became one big drip.

As well as highly commercial images, which are for the bank manager, I also take images that are different from the norm. When the dolphins started bow riding the boat, I decided to blur their motion instead of freezing it, as it seemed the perfect way to show their elegance in the water [Canon EOS-1v, 17–35mm f/2.8L lens, Velvia, f/16 at 1/30sec]

Preparation

Calendar images have to be perfect, so preparation was all-important.

▼ I loaded both EOS-1vs with Fuji Provia 100F slide film. Calendar clients like images that are bold, bright and of exceptional quality, so it was either this film or Velvia. I chose the 100F to give me the extra bit of shutter speed that would freeze the dolphin's jump. I used an 81A filter to warm everything up to Velvia standards.

▼ I knew that the TTL light meter would be fooled by the bright sunlight reflecting off wet dolphins. As the light was constant between the boat and the dolphins, I also knew that I could trust my handheld light meter. It showed 1/1000sec at f/5.6, which I hoped would be fast enough to freeze even the most gymnastic dolphin mid-flight. I could have used an aperture of f/2.8 and given myself 1/4000sec but I wanted some depth of field in the shot. I switched my camera to manual, dialled this value in, and set the auto bracketing for one-third of a stop either side.

▼ Finally I set the autofocus to AI servo (tracking) and lit up all 47 focus points. The action would be fast and furious and, from experience, I knew the camera would handle it better than I would.

Spare cameras

You can see the benefits of having two camera bodies. It doesn't matter whether they are top-of-the-range models or cheap and cheerful. With the active and potentially dangerous photography that I do, it is only a matter of time before one of the cameras cries out for mercy and the comforts of a repair shop. If a camera is wet by fresh water, it is no real problem; just dry it off with a towel. However, salt water is a real enemy of cameras, as it corrodes. When the dolphins drenched my camera, I stripped it down and dried it thoroughly, piece by piece, but even though I did this as soon as possible, it just wasn't quick enough.

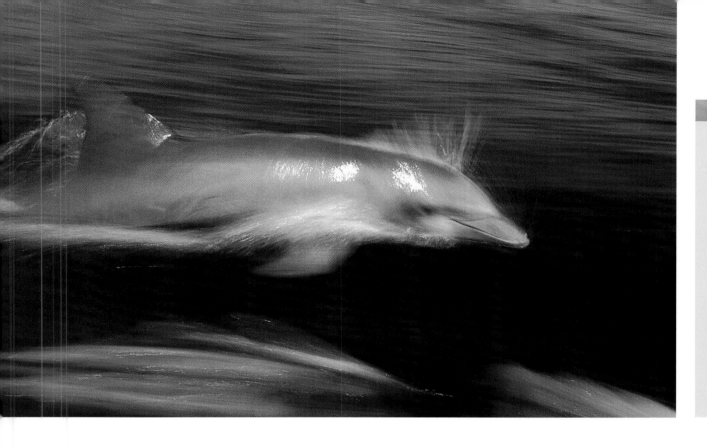

Tracking autofocus

Tracking autofocus works well if you give it time. Too many photographers expect the servo/tracking autofocus to lock on straight away; it needs a few seconds to predict the motion of the subject. As soon as the dolphins broke the surface of the water I locked onto them, so I was confident of the autofocus tracking them by the time they reached the apex of their jump.

The morning flew by and before we knew it, lunch time had arrived. We met again an hour before sunset as Brandon and I wanted to try to get some atmospheric jumping shots. The dolphins were in a playful mood again and duly obliged, jumping beautifully against the evening sky. Just as the sun was about to set and give me a killer shot, clouds appeared – from nowhere – on the horizon and blocked out the setting sun. This happens a lot at sea and is one reason why I always try to allocate several evenings to this kind of work. These clouds looked ominous and I went to sleep that night dreading what the morning would bring.

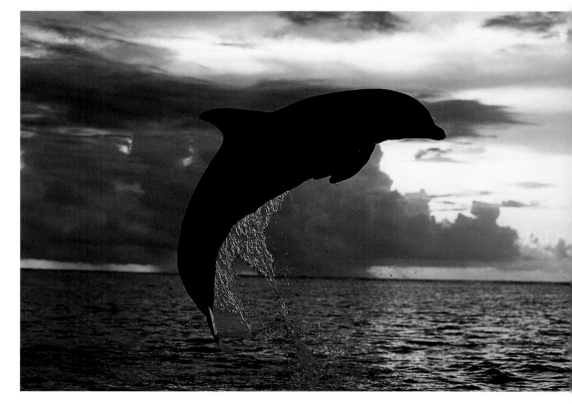

Using the silhouette technique outlined on p 28, I set the camera up before capturing these acrobatics [Canon EOS-1v, 70–200mm f/2.8L lens, Velvia pushed to 80, f/2.8 at 1/125sec]

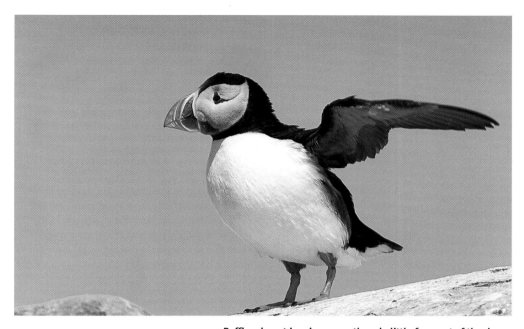

Puffins do not inspire me as they do little for most of the day. In fact, this is about the most active puffin I have seen! Unfortunately, I couldn't get full on to the puffin due to an obstruction – a jobsworth – so had to settle for this shot instead [Canon EOS-1v, 70–200mm f/2.8L IS lens, Velvia, f/5.6 at 1/500sec]

Finding kingfishers

I found the kingfisher site using my tried and trusted technique. A farmer told me that he regularly saw kingfishers flitting along the river, so I walked up and down and noted where they were sitting. I did this in late March as this is the time kingfishers establish joint territories for the breeding season. When the breeding season was in full swing, it was then just a case of sitting and watching where they flew when their mouths were laden with fish. Eventually I found their nest bank. I set the hide up at night to avoid any disturbance to the parents.

Kingfishers

After the relative success of the fox shoot, I spent the next week or so preparing shoots for the following month. I checked my local kingfisher nest from a distance, using binoculars, to avoid disturbing them; they were flitting in and out of the nest at 15-minute intervals.

I decided to leave the photography for another few weeks, until the young were out of the nest: this would yield more varied shots. I left my hide in place so that the kingfishers would get used to it, hoping no-one would walk off with it in the meantime.

Seabirds

June is a great time for seabirds in the UK and my collection was in need of updating. Clients get tired of seeing the same old work and are always looking for fresh material, so it pays to repeat easy subjects such as these every couple of years. Difficult mammals, like foxes, hares and deer, I take when the opportunity arises, but seabirds that just sit and stare at me all day present little challenge, except to my patience.

The Farne Islands

My first stop for this task was the Farne Islands (off the north coast of England), home to a very accessible and busy seabird colony. Some photographers like the experience of hanging off cliffs by thin ropes, but I like the comfortable experience of these islands. The only difficulty is that taking photos on them is always a race against time: the boat only drops its passengers for a couple of hours on each island. This particular morning the boat was full of tourists. Billy, the captain, motioned for me to sit at the back. Five minutes later, as we left the sheltered harbour, a strong wind and swell crashed waves over the side of the boat. I smiled at the sight of the tourists, in their impossibly untrendy trousers, getting soaked. It is the little things that warm my day.

Two hours passed quickly and it was soon time to leave for the next island. The tourists, who had now dried out, were enjoying the sunshine. I smiled knowingly at them for they had no idea what was coming. Once the boat docked, the few of us who had been before waited behind as the tourists set off up the main path. Within seconds the air was full of wheeling Arctic terns who

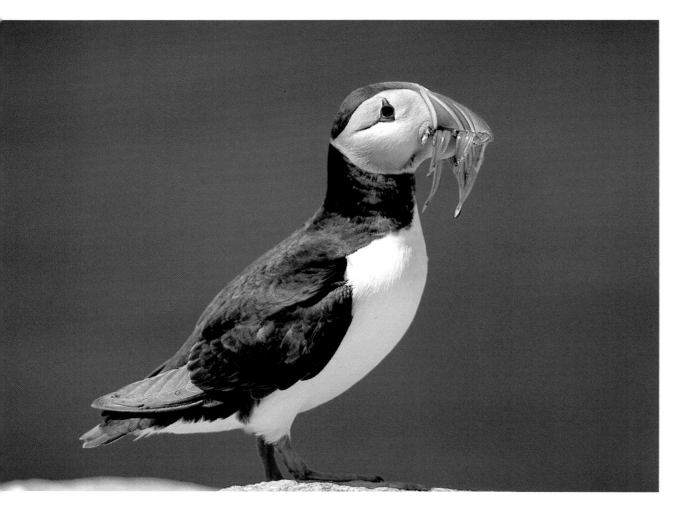

This shot is one that everyone wants, but getting it with a clean background is a nightmare and a trial of patience. After burying the jobsworth who obstructed the previous picture, I sat down in a likely spot and waited. The light was very harsh and produced unflattering shadows so I used an 81A warming filter to cut down the glare [Canon EOS-1v, 500mm f/4L IS lens, Velvia, f/8 at 1/500sec]

Photographing puffins

The Farne Islands are best known for puffins and although they are very tame, it is surprisingly difficult to get good, clear shots of them. Most sit around in colonies which means that simple, isolated shots of an individual are difficult. There is nothing more annoying for a commercial picture editor than having a beautifully exposed bird in the foreground with two out-of-focus white blobs in the background. So, I always look for a small group of birds sitting apart from the rest, with good light shining directly on them, and a clear backdrop behind. I use my depth-of-field preview function to check this, as it always pays to keep backgrounds as simple as possible. If I can't get isolation, I have to use a much higher depth of field – around f/16 – to get the whole group in sharp focus.

proceeded to dive-bomb the unsuspecting tourists, pecking the tops of their heads and even drawing blood from a few. We tried not to laugh. The time came to run the gauntlet ourselves. I have a simple solution. I open the tripod and put it on my head – the terns can peck at the metal all they like. At the top I passed the by now irate tourists and decided to try for some shots of terns hovering in the wind.

The sea provided a beautiful backdrop. As I become more proficient with the box brownie, I find I enjoy taking abstract views of wildlife a lot more. I took some 'boring' shots of terns from the front, they would sell, but my favourite shots came from behind.

Bass Rock

After the excitement of the Farne Islands I moved up the coast to the site of my favourite seabird colony – Bass Rock. This is home to thousands of gannets. As its name implies it is a lump of rock, and it juts out of a very rough sea. Landings are difficult but local boatman Fred Marr is experienced at getting photographers on and off the treacherous island. A grinning George McCarthy, a great mate and fellow professional, welcomed me onto the boat with some good-natured abuse. He was leading a photography group. Five minutes later, bouncing up and down on the swell, I was under no illusion as to what the landing would be like. We reached the rock, with the boat edging perilously close to leaving us with a long swim home, then it was just a question of timing our jump off as the boat rose up to meet the steps.

The first thing you notice about Bass Rock is the smell. Seabird colonies are generally very smelly places but Bass Rock wins the nose-assaulting prize. The second thing you notice is the noise – the sound of the gannets as they wheel around the rock is deafening. I clambered to the top, away from George's tour group, and looked for a small gathering of gannets sitting in isolation from the masses. I found some likely victims sitting on the edge of the path. They squawked at me loudly when I approached but after a few minutes of my hand waving and choice language, decided I was not worth the bother. I spent the best part of four hours with these gannets who seemed content to just stare at me with quirky interest.

After a pleasant few hours with my new friends, George came by and dragged me off to get some flight shots. Most professionals would not be so open and friendly but George and I have always had a great working relationship. The strong wind was creating superb conditions for flying; I tried to

Preparations

The jump up from the boat was made easier by the fact that I had left most of my equipment at home. On my first visit to Bass Rock I made the mistake of bringing my 600mm lens, which stood unused by me but provided a handy gannet perch for most of the day. I learnt my lesson and this time brought the absolute minimum gear, but plenty of corned beef and piccalilli (a pickle and mustard relish) sandwiches. The longest lens I had was my 70–200m, f/2.8, which could become a respectable 300mm if I used my 1.4× teleconverter. Everything fitted neatly into my Lowepro Street and Field rover rucksack, which was small enough to wear all the time.

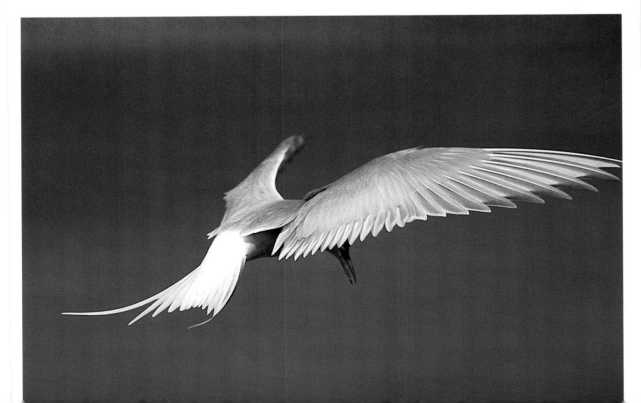

Some will call it art, some will wonder where the head was, and quite a few will think that I have lost it big time. My major headache was ensuring that the depth of field was enough to keep the wings and body sharp, without using a shutter speed so slow that it caused blur. Luckily the tern hovered in the wind, which solved the latter dilemma [Canon EOS-1v, 70–200mm f/2.8L IS lens, Velvia, f/8 at 1/200sec]

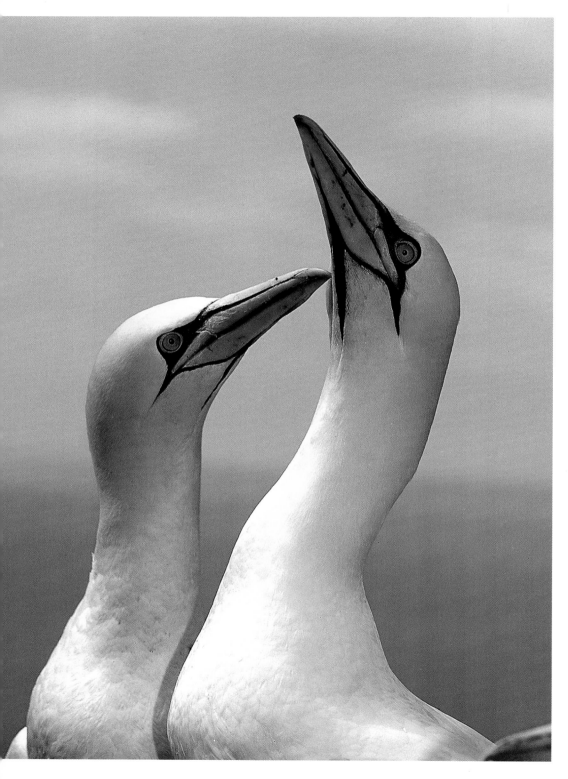

flap hard but could not lift off, George just shook his head and walked away. The gannets wheeled and dived all around me – it was a fantastic sight to see the blue sky full of shining white birds.

I left Bass Rock with some wonderful memories and my hair full of bird droppings. It is a truly wonderful place to go but, unfortunately, one that the Royal Society for the Protection of Birds (RSPB) want to stop all access to. To this end they have built a visitor centre on the mainland, including a coffee and souvenir shop, that provides live video viewing of the birds on the rock. I do hope that by the time you read this Bass Rock will still be open to visitors as it offers a truly memorable experience.

This was a total grab shot so apologies for the dodgy horizon. I used a fill-in flash here to soften the shadows, compensated by minus three stops to ensure that the subtle effect remained [Canon EOS-1v, 70–200mm f/2.8 IS lens, Velvia, f/11 at 1/60sec]

Flight shots

To get them right, flight shots require a bit of preparation. I set the camera autofocus to one shot, as the servo/tracking focus would have a nightmare with so many subjects to choose from. The trick is to sort out your composition, hold the camera steady, and take the shot when the frame is full of birds. I took a reading from the handheld meter at f/8 (chosen to give sufficient depth to the shot), then darkened it slightly to bring out the sky. Finally, I used an 81A warm-up filter to greatly intensify the blue of the sky and used my 17mm lens to get the shots. I love using this lens as it is very forgiving regarding depth of field, seems to focus very well, and always gives wonderful sky effects.

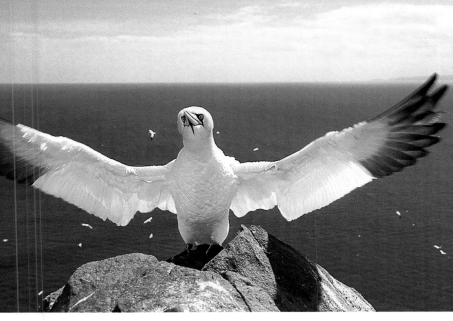

Caught at the instant of take-off, another grab shot where I had only seconds to react. I had already compensated the light meter by plus one-and-a-third of a stop to counter the effect of the bright sunlight on the white feathers, and this saved me precious time [Canon EOS-1v, 70–200mm f/2.8L IS lens, Velvia, f/5.6 at 1/250sec]

For once not a grab shot. I spent an hour with this one gannet as we discussed its life in detail. As it preened I composed the shot to lead the neck out of the bottom corners to the beautiful shape of the head [Canon EOS-1v, 70–200mm f/2.8L IS lens, Velvia, f/11 at 1/60sec]

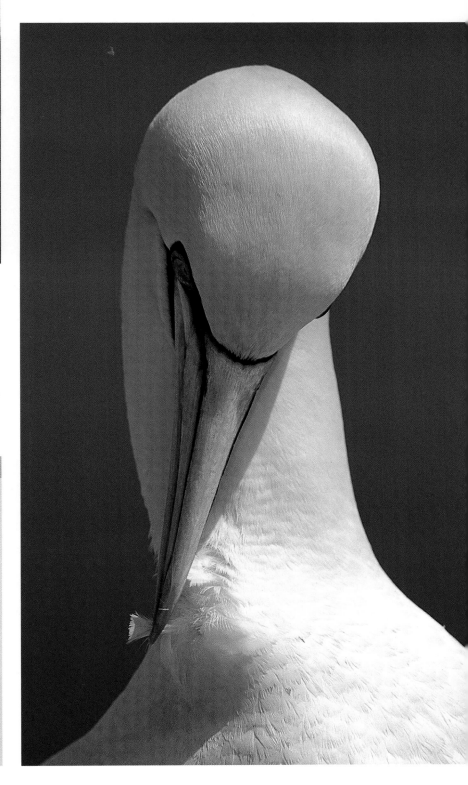

Photographing gannets

Seabird colonies are alive with action and can be very confusing for inexperienced photographers. My advice is to concentrate on one particular group of birds, as they will perform happily for your camera once they become relaxed and settled in your presence. Photographically, the main obstacle to getting great pictures of gannets is exposure, as they are a bright, shining white. On this particular day the sun was in and out of clouds, so I took two sets of exposure readings with my handheld light meter, one for the sun and one for the more diffuse cloudy light. I dialled the sunny setting in manually so that when the sun went in, I could just flick the compensation dial quickly to give me the other reading. I have been to Bass Rock and compensated the reading through the lens (usually two stops in sunlight), using rock tones as a base exposure, but this can be a little hit and miss. The handheld meter tells fewer lies.

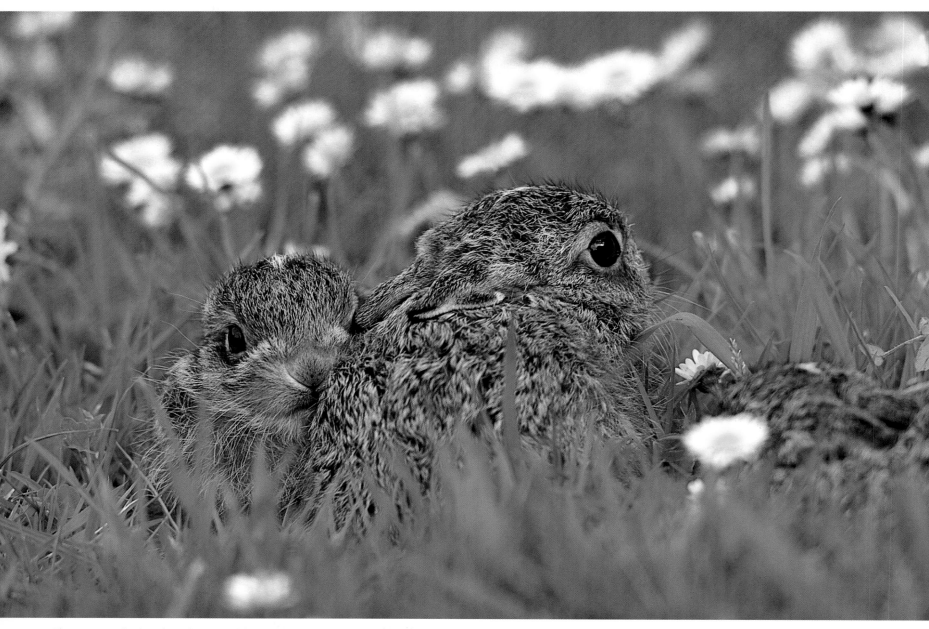

I love young animals. It is such a rare privilege to get this close to wild leverets in such a pretty habitat that I couldn't resist taking several films of their antics. At the end of their frolicking they just lay down to rest; I carefully locked the autofocus onto the leveret's left eye and used f/8 to bring everything into focus [Canon EOS-1v, 500mm f/4L IS lens with 1.4× teleconverter, Velvia, f/8 at 1/125sec]

Osprey heaven

My priority now was the annual roe deer rut, which always begins at the end of July. I am slowly building a complete collection of roe deer behaviour – in preparation for a future project – and this was a vital time of year for my efforts. Unfortunately, the roe bucks showed little if any inclination to chase anything remotely female. After two dismal days in the office I was going stir crazy when an email from my Finnish friend Ahti Putaala popped up. 'Have found a great place for ospreys but you need to come over to Finland now,' it said. Two days later, after several phone calls and a lot of help from Finnair, I stepped off the plane in rural Finland. I was taking a risk leaving England, as I knew that the roe deer rut would start soon and I might miss the chance of getting some really saleable pictures, but wildlife photography in the UK is becoming increasingly difficult as the number of rules and regulations governing it increases. The RSPB (Royal Society for the Protection of Birds) also suffers from red tape and the chance of me getting any information about ospreys from anyone is as likely as me singing in a choir. So, this osprey opportunity was a golden one and the choice, thought of in purely commercial terms, was easy.

Several hours later I was sitting in a hide, complete with bunk beds, watching an amazing spectacle unfold before me. It was late and much too dark for photography, but one osprey after another splashed down into the pool in front of me. They emerged with struggling trout fixed in their talons, silvered water raining down as they lifted into the air. I just could not believe my luck and went to sleep with a smile on my face and the sound of repeated splashes outside.

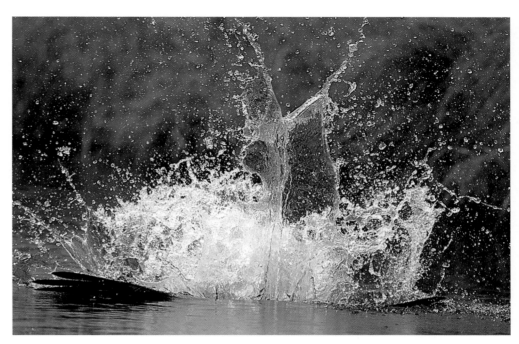

The initial splashdown, caught in full glory by selecting an aperture of f/2.8 which, by definition, selects a very fast shutter speed [Canon EOS-1v, 300mm f/2.8L IS lens, Provia 100F, f/2.8 at 1/2500sec]

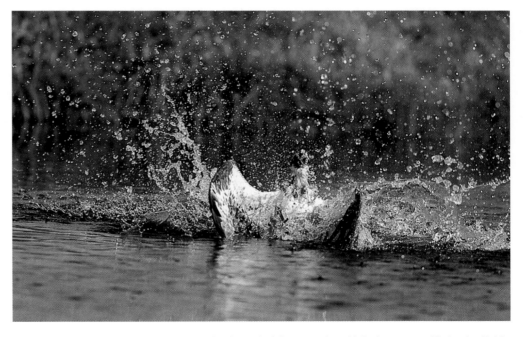

A very stunned and confused osprey seconds after splashdown; again, a high shutter speed helped nail this shot [Canon EOS-1v, 300mm f/2.8L IS lens, Provia 100F, f/2.8 at 1/2500sec]

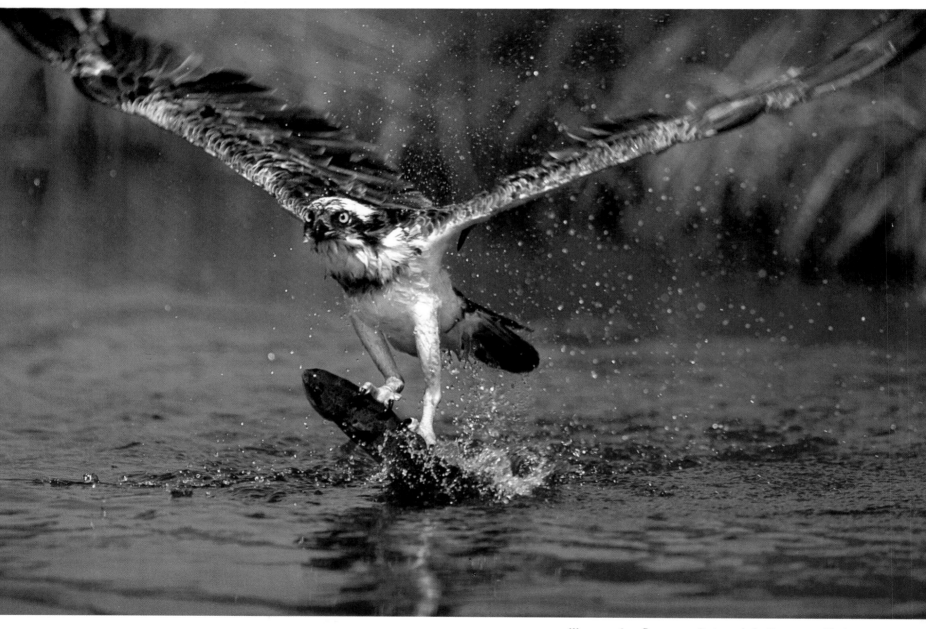

Wow man. A surfing osprey. Party on dude. Ermm sorry, I just love the Bill and Ted films. The action was far too fast for me to remember getting this; everything was shot purely on instinct. Most of the time I failed to get the lens in position in time, but this time I was there at the splashdown, so when the osprey erupted from the water, the focus was already locked on. A cool shot [Canon EOS-1v, 300mm f/2.8L IS lens, Provia 100F, f/4 at 1/1250sec]

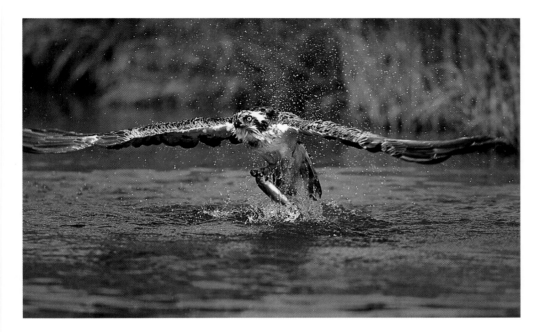

A second later than the first shot, the fish is now clear of the water and with the next wing beat the osprey was out of the frame. With flight shots it is important to get the wings up rather than level, as it looks more dynamic. Technically the surfing osprey is therefore better, although this is a nice shot in its own right [Canon EOS-1v, 300mm f/2.8L IS lens, Provia 100F, f/4 at 1/1250sec]

Next morning the osprey alarm clock woke me at 4am, when their fishing day began. The sky was full of circling ospreys once more and, although the light was too low for any photography, I spent my time trying to predict their behaviour and setting up my camera gear.

The ospreys were hunting from behind the hide which made my chances of photographing them entering the water very remote indeed. I watched every single osprey that flew overhead and gained the knowledge to predict which ones would hunt in this pond.

When they seemed ready I would get the lens pointed into the hot spot (where the fish were feeding), keeping one eye looking through the viewfinder and the other watching the whole pond. When the splash came I had only seconds to get the lens on the osprey before it lifted the trout clear of the water. As the hours went by I started to get more than just the ospreys' tails in the frame!

Preparation

The action was fast and furious so it was important that I set the cameras up correctly first time, as I would only have seconds to react to an osprey splashdown.

Cameras
I attached my hired 300mm f/2.8 lens to one EOS-1v body and a 70–200mm f/2.8 to the second EOS-1v. I didn't even consider using the digital camera as its autofocus was just too slow.

Exposure
I knew that the white breast of the osprey and the resulting water splash would convince the camera's light meter that there was more light than there actually was, which would result in an underexposed image. Being stuck in the hide, I couldn't use the handheld meter so, instead, pointed the camera light meter at several different reference points of brown-green grass and an old shack at the edge of the pond. All of these had even tones, nothing too white or black, so I took the best average. I then changed the EOS-1v to manual mode and dialled this in at an aperture of f/2.8. Providing the light stayed the same I'd be OK.

Film
My choice was Provia 100F pushed to ISO 200 for extra speed.

Autofocus
I set this to AI Servo and lit up all 47 focusing points. The camera's job was to lock onto the osprey and track it; mine was to keep it roughly central in the viewfinder.

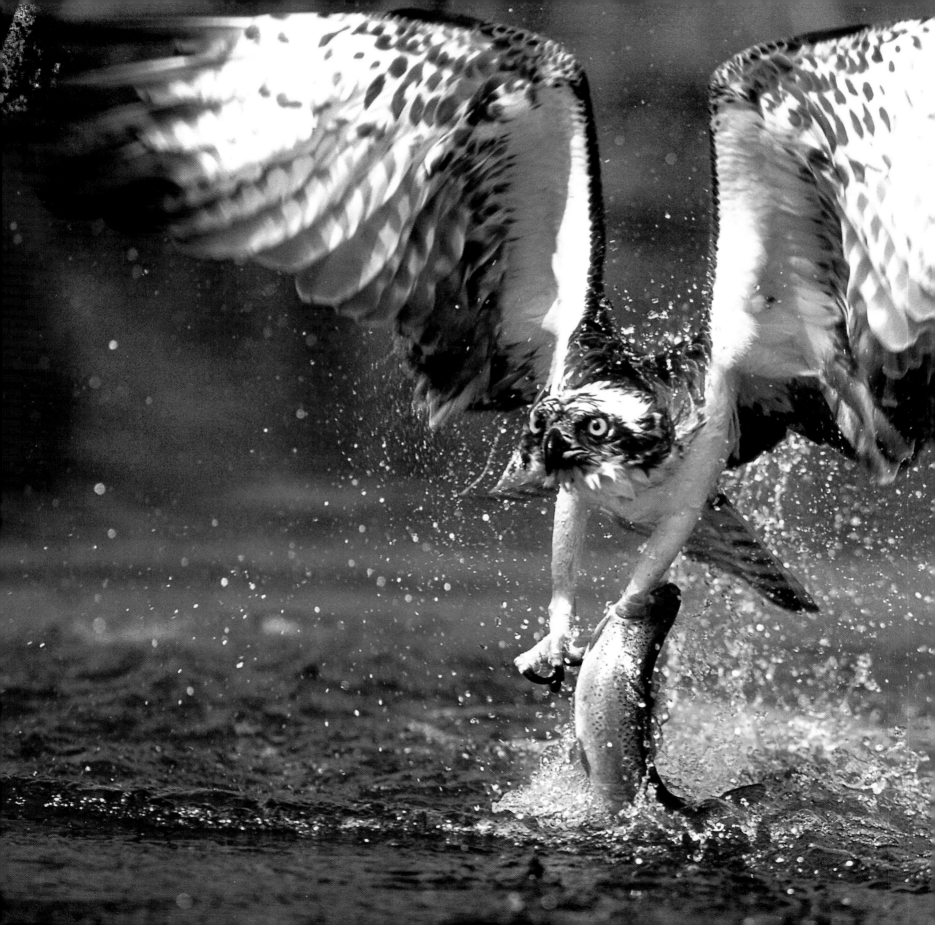

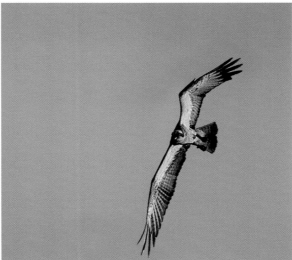

A rare shot of an osprey starting its dive. I took this in the evening when the light on the pond was too sidelit, but in such a wonderful place I knew I could always find something of interest. As the light was very low I only compensated by plus one-third of a stop for the sky [Canon EOS-1v, 300mm f/2.8L IS lens, Provia 100F, f/4 at 1/250sec]

Over the next six days I had plenty of opportunity to watch and learn, and I developed a routine: work in the morning until about 11am, when all went quiet and the ospreys hung around their nests, leg it out of the hide to the nearest supermarket to get salami sandwiches, crisps and water, then straight back to the hide for 1pm. I'd generally photograph until 8pm, when the light finally disappeared, then tuck myself up in bed for the night, listening to the repeated splashing sounds outside. It was an amazing week and I can't wait to return again next year.

Gear box

- ▼ Canon EOS-1v bodies with NiMH drives × 2
- ▼ Canon 300mm, f/2.8 image stabilizer lens
- ▼ Canon 70–200mm, f/2.8 image stabilizer lens
- ▼ Canon 1.4× teleconverter
- ▼ Fuji Provia 100F × 60 rolls
- ▼ Fuji Provia 400F × 30 rolls
- ▼ Double beanbag

I knew, from prior experience with ospreys in Scotland, that I would need the fastest lens I could lay my hands on. The 300mm f/2.8 seemed the obvious choice, the only problem being that I didn't have one. My solution was to hire one, and I have done this many times since. Apart from that, everything else for this trip was standard. The choice of film was pretty easy; I needed to use Provia 100F for the quality (Velvia, in this case, would just be too slow) and decided to take 400F as well in case the weather was awful.

The best shot of the trip and it still amazes me how this osprey is hanging on to the trout with just a couple of talons [Canon EOS-1v, 300mm f/2.8L IS lens, Provia 100F, f/4 at 1/1500sec]

August is usually a quiet month for my wildlife photography, as most of my subjects seem to be on their holidays. Mammals such as water voles, deer and badgers are very visible, but by this time fox cubs are too aware of what humans are to let me close. Sometimes I am lucky and the kingfishers have a second brood, as do the barn owls in good years, but this was not one of those years, so I threw myself into getting up close and personal with my local roe deer. I find deer absolutely fascinating creatures. They also present serious challenges to me in terms of fieldcraft, as they see me as just another predator.

August

Lurking in the forest

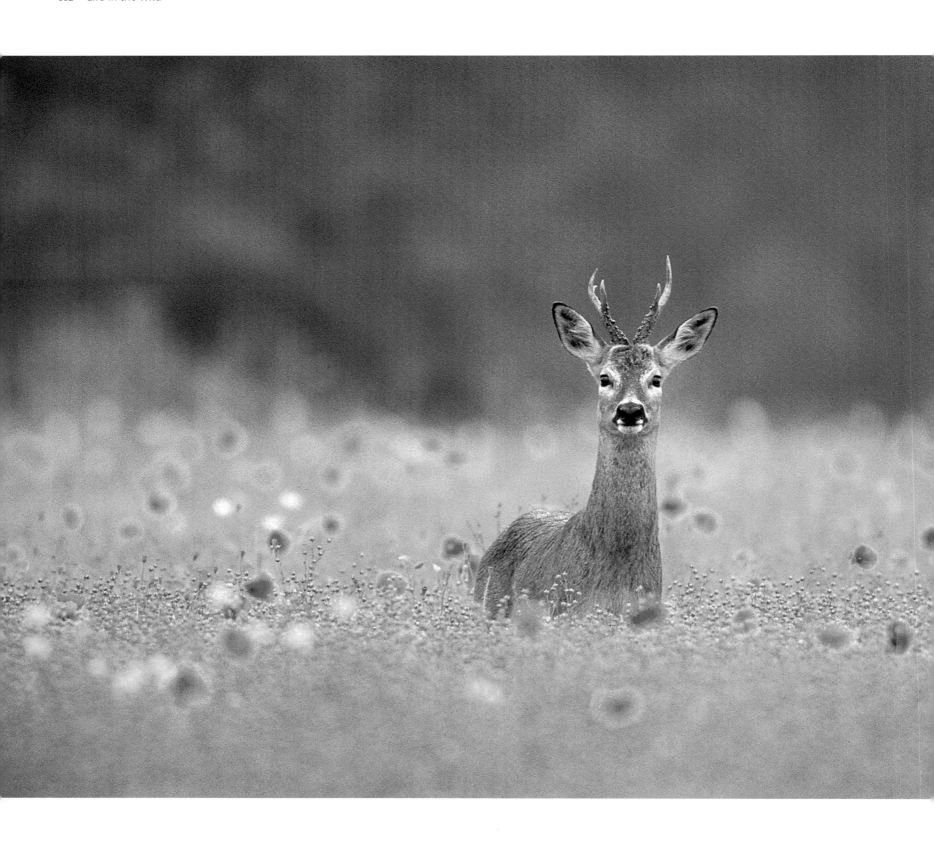

Roe deer

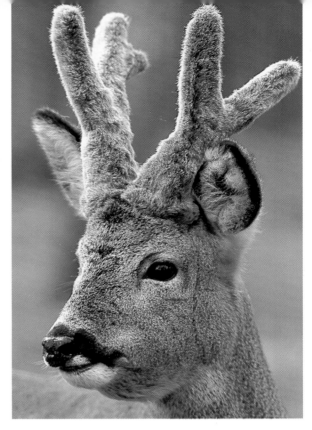

I just wanted to show the contrast between a summer buck (opposite) and a spring one with velvet (above) [Canon EOS-1v, 100–400mm f/5.6L IS lens, Velvia, f/8 at 1/60sec]

The morning breeze blew into my face as I crept slowly forward. I was nearly there. For once the buck I had been chasing for months was within range and totally unaware of my presence. It had taken me half an hour of painstakingly slow steps to get this close; a few more and I would have a clear shot. Crunch. I am the kind of guy who would step on the only twig in the desert and today I found the loudest in the wood concealed, as they always are, under leaves. The silence was shattered, the buck immediately stared at me, and I knew the game was up. In a second he was gone, back in the woods, gruffly barking a warning for all to hear.

I stalk roe deer all year round, but it is during the rut in late July and early August that my encounters are at their peak. I say 'encounters' as deer photography presents the ultimate contest of my wits and skill against theirs. Depending on how good I am on the day, an encounter can last between one second and five minutes. A good picture of roe deer is always the result of 99% skilful fieldcraft and 1% happy snapper.

Deerstalking is my way of honing and developing my fieldcraft skills. With these I can have greater success with more dangerous animals – such as grizzlies, elephants and rhinos – that could inflict fatal injuries if I made just one mistake.

Deer live in a different world from us, a world where danger lurks around every corner, waiting to trap the unwary. In the UK the only danger presented is from humans but the deer have inherited self-preservation tactics from their ancestors who lived in a world of wolves and lynx (as they still do in eastern Europe). This means they are constantly using their highly developed senses to detect any signs of danger – a strange scent on the wind, a movement in the trees or a shape on the horizon. Any of these will invoke an automatic response – move the other way, and fast! The key is to fool these senses by becoming a ghost. Ghosts allegedly have no smell or shadow and often no visible presence, making them the perfect guise for outwitting any mammal. Unfortunately, most mortals are not able to adopt these skills at will, but there are a number of sneaky tricks that I use to achieve the same results, without scaring the neighbours.

Proof that persistence, fieldcraft and patience can yield great results. To shoot the picture any tighter would have been a crime against the natural world. The judges gave it Highly Commended in the 2001 BP Wildlife Photographer of the Year competition [Canon EOS-1v, 70–200mm f/2.8L IS lens with 1.4× teleconverter, Velvia, f/5.6 at 1/60sec]

Licking the nose is a telltale sign that a deer has caught your scent and is trying to pin you down. In this case it must have been exhaust fumes from my Jeep, but she didn't run as deer on this estate are used to vehicles. I deliberately set the aperture to f/5.6 to blur the background and maintain the focus on the deer [Canon EOS-1v, 600mm f/4L lens, Velvia, f/5.6 at 1/125sec]

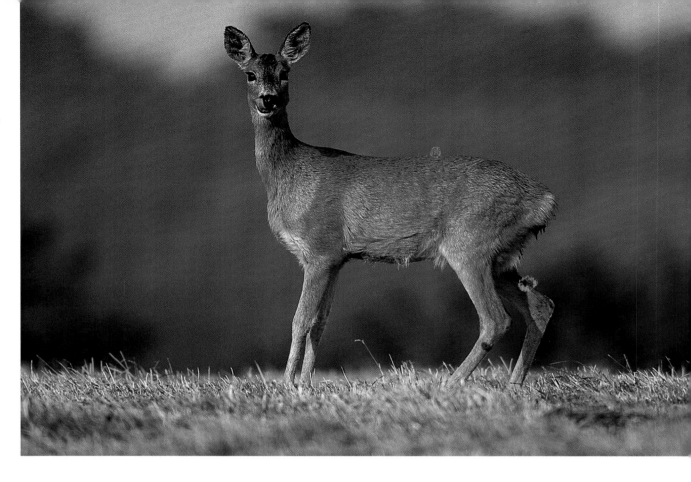

The Rouse School for ghosts

Trick No. 1
Deer can smell humans from a long distance so I never go out stalking smelling of aftershave. Keep any stray smells locked away under a well-buttoned jacket. It goes without saying that your outer layer of clothing must be stored away from household smells; mine lives in the car and has never been washed, which is nice on a long drive...

Trick No. 2
Always walk with your face into the wind. This is an old gamekeepers' trick that I picked up and it always works with any mammal.

Trick No. 3
To reduce the chance of being seen, I camouflage myself from head to toe (see p 125).

Trick No. 4
Be aware of what is around you at all times; in other words, concentrate. This may sound obvious but losing concentration for just one second has caught me out in a big way. A few years ago I was asked to conduct a master class and take an amateur to photograph roe deer. We met one morning at 4am, all togged up in camouflage gear, and made our way quietly to a place where I knew deer would be lurking. In the gloom I checked the surroundings and could see nothing, so we very carefully climbed over the gate and into the field. I stepped down first and turned around only to look straight at the dominant buck, not 3m (10ft) away. We stared at each other for a minute, then he ran off and barked for a solid half hour. Needless to say, we did not see any other deer that day.

Fieldcraft

Come with me now on some encounters that show the benefits of good fieldcraft, and of stubbornness!

Doe and fawn

At the start of the month I called all my local stalkers to see what was around. A return call from one told me of a doe and fawn seen regularly in one particular place. I arrived at the field mid-afternoon, when I knew that the deer would be sleeping in the cool of the nearby forest but checked, just in case, through binoculars. Carrying my long lens in one hand and my beanbag in the other, I walked straight across the field towards a ladder that disappeared into a tree. As soon as I reached it I hauled my gear up the ladder; some 4m (13ft) up was a seat firmly lashed to the trunk of the tree. Now, before you start to wonder, it was not a coincidence that the seat was there. One way that I defeat a deer's senses is to use an old deerstalker's trick called a high seat. This is, as the name suggests, a seat in a tree, usually set to overlook a regular deer hot spot. A high seat works, and it always amazes me how well they work, where the local deer have no fear of airborne predators, which means they have no fear of anything attacking from above.

A lovely shot using f/4 for once to ensure that the surroundings are totally out of focus. The autofocus had a nightmare with the blades of grass; selecting all 47 points helped convince it to lock onto the deer in the centre of the frame [Canon EOS-1v, 500mm f/4L IS lens, Velvia, f/4 at 1/125sec]

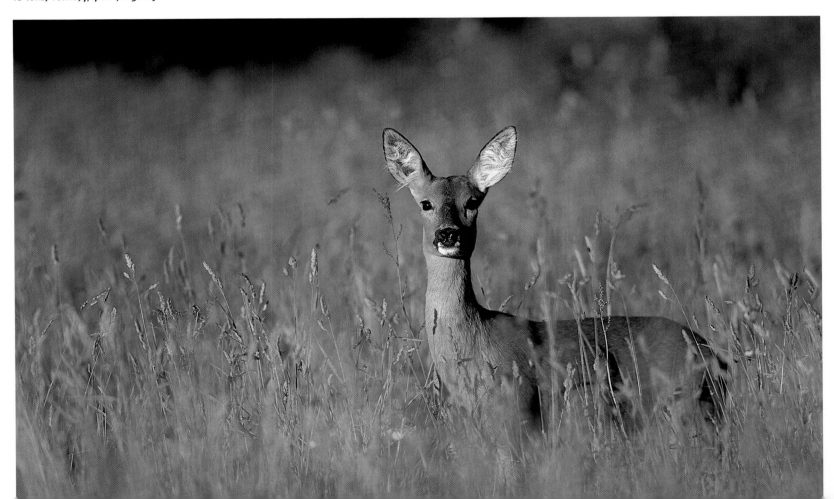

Travelling light

When stalking I always travel light. I have attempted to stalk deer whilst carrying a huge lens, a tripod and a rucksack. I say attempted because it ended in dismal failure; the equipment clanked and clunked like an old steam engine and weighed so much that my mobility was severely restricted. This day I took my favourite combination of 70–200mm, f/2.8 image stabilizer lens with a 1.4× teleconverter. The combination is quick, flexible, and easy to keep camouflaged, and the image stabilizer helps me shoot in bad light conditions.

After a wait of about three hours the mother duly appeared, walked up the bank, and sat down in the evening sun. The fawn, following closely behind, immediately went up and nuzzled her. It was a wonderful moment and one that I felt privileged to photograph. High seats are great for avoiding detection but are severely limiting in terms of positioning: once you are there you cannot move. I generally use high seats for watching an area to see what animals are around and where they are likely to emerge from cover. I can then plan a way to get closer to them on foot.

Attracting a buck

By now all signs pointed to the rut being in full swing and it was time to concentrate on my local estate. During the annual rut, testosterone-fuelled bucks strut around trying to impress the ladies and get a hot date. They have only one thing on their mind and, because of this, are easier to get close to than at any other time. Notice I say easier and not easy.

When checking my sites the month before, both from the Jeep and from a high seat, I found a field that was home to several large bucks. I find getting up at 4am a real killer, must be my age, but for deer I always manage it. I parked my Jeep well away from the site as nothing interests a deer more than a slamming car door or a squealing brake. Slipping over the gate, and making my eyes water in the process, I first checked the wind and found that my approach would be perfect. I covered the first 100m (330ft) or so in about 20 minutes – deer photography is not a speedy business. Before each step I looked down to see what I was treading on, then checked what was behind me to make sure that I was not standing in silhouette against a gap in the hedge. Every step brought me closer to a potential picture or potential discovery – there is a fine line between the two.

Rounding a corner I saw a big buck off in the distance and started to work along the hedge towards him. I had checked the wind again and smiled as I felt the cold breeze against my face: at least he wouldn't smell me. After a few minutes, using the shelter of the hedge as a natural hide, I slowly poked my head out to see him grazing in front of me, some 100m (330ft) distant. It was a beautiful scene, but the buck was too far away even for a landscape-type shot. I had no choice but to bring him to me. During the rut it is possible to imitate the call of a doe and bring a buck in very close, sometimes frighteningly close, to a hidden

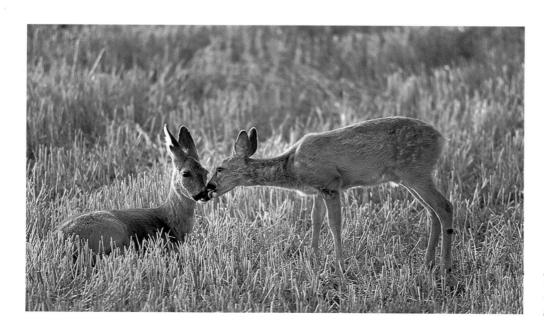

An example from the high seat. To get this intimate shot, which would be impossible from the ground, I balanced my 600mm lens precariously on a beanbag [Canon EOS-1v, 600mm f/4L lens, Provia 100F, f/8 at 1/60sec]

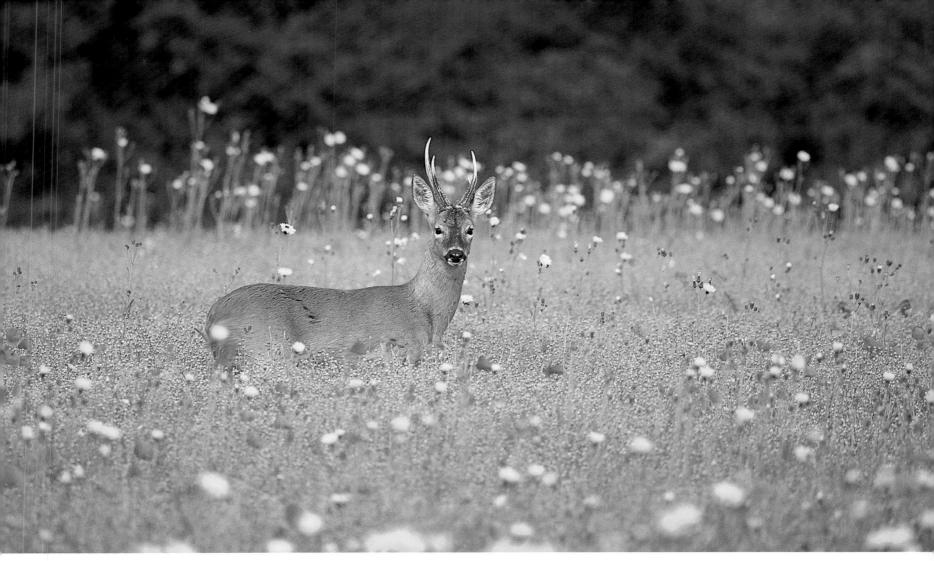

position. I had been practising for weeks, now was the time to put it to the test. One mistake, one wrong pitch, and my opportunity would be lost. I gave it a try. The buck immediately looked up, so it was now vital that I didn't move a muscle. Taking a picture was out of the question: he was already suspicious and I needed him a lot closer. I paused for a few seconds before calling again. He stared intently then stamped arrogantly towards me. This was my chance. I let him get to about 15m (50ft) before taking the first picture. I didn't want him any closer than this as he might not take too kindly to being tricked.

Slowly, I locked the autofocus right between his eyes, held my breath and pressed the shutter. I had the camera set to autobracket at two-thirds of a stop as I had developed an inherent mistrust of the meter. I took a series of 12 shots, taking snaps at random times as nothing scares an animal more than the sound of a machine-gun shutter. Taking the smaller lens was the right decision as it allowed me to include all of the poppies in the shot, which makes the picture special. My view is that with a big lens, once you are too close there is nothing you can do as it is difficult to back off, but with a small lens you can always get closer.

Even with the wind perfect, and decked out from head to toe in the finest camouflage gear, I had only seconds to get this series of shots before he decided I was not a female and stomped off [Canon EOS-1v, 70–200mm f/2.8L IS lens with 1.45 teleconverter, Velvia, f/5.6 at 1/60sec]

Running buck

Of course, sometimes I am just in the right
place at the right time. I was out one morning
photographing baby rabbits – hardly dangerous
I know but it does pay well – when a chance
encounter yielded my most commercial deer shot
to date. I was under a grassy knoll when suddenly
a doe appeared on the top, panting furiously.
She had obviously been running from something;
her eyes were wide open and she was totally
unaware of my presence. I managed to point my
lens on her just as she started running again, then
saw the reason for her flight about 5m (16½ft)
behind her. A magnificent buck was standing
staring at me. Deciding that the female was getting
away, he pranced off after her right along the
horizon. I had time to get five pictures before he
was gone though in total the whole encounter had
lasted less than 10 seconds.

It took a week or so to get the picture back and
wow, I had caught him mid-leap. I knew exactly
how commercial the shot was and wasted no time
in emailing a lo-res version to everyone on my
client list. Within hours I had received several
requests for a higher quality version, so I sent it off
for drum scanning.

*Time was of the essence with this shot; everything had to be
set within seconds. I always practise setting my camera
controls without taking my eye from the viewfinder, so
I quickly changed the autofocus to tracking, lit up all 47
autofocus points, and selected f/4 to get the maximum shutter
speed. I then tracked his motion, waited a few seconds until
the predictable autofocus had locked on, then wham! [Canon
EOS-1v, 500mm f/4L IS lens, Velvia, f/4 at 1/250sec]*

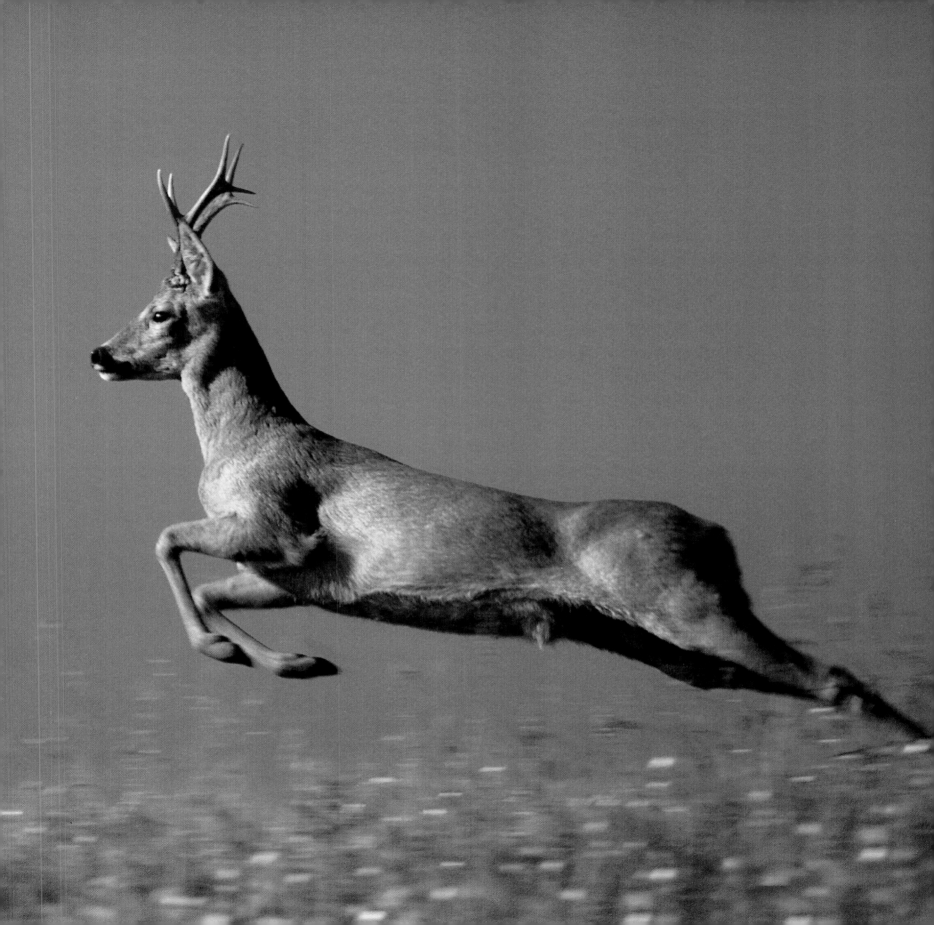

Ok, so it's not the most action-packed seal shot I have, but considering the bobbing boat, it is very acceptable. The shot is simple, with a nice, diffuse sand background, good light in the eyes, and a nicely coloured coat. A lovely animal [Canon EOS-1v, 500mm f/4L IS lens with 1.4× teleconverter, Provia 100F with 81A filter, f/8 at 1/400sec]

Seal colony

I had dedicated nearly two weeks to the rut and now I needed a rest so, like my Victorian predecessors, I went to the seaside. Actually, to a new seal colony that I had just read about. Margate sandbanks sit in the middle of the Thames Estuary and are only exposed for a couple of hours every day, at low tide. During this time the sandbanks are a haul-out point for passing common (or harbour) seals, and I had precisely zero pictures of these mammals in my files. I arrived at 5am, in time to see the sunrise, and found the boat that I had chartered for the day. I love working from boats and this one was a real beauty – a 100-footer complete with swirling sails. We made slow progress to the sandbanks but as we got closer I could see the dark shapes of seals ahead, the signal for Captain Mike to start tacking back and forth. All animals, large and small, have a safety zone, a minimum distance from them that they will let anything approach. One way of tricking them into letting you into their safety zone is to move forward in long arcs, from side to side, getting closer with every sweep.

After around 30 minutes we had reached the closest point that the seals would tolerate – some of the more nervous ones had already chosen the safety of the water. Being on a sailing ship definitely helped, as its silent approach allowed us to bring them within range of my camera.

At the end of our final tack we reached the end of the sandbank to find an uninvited but very welcome guest – a grey seal bull. He was magnificent and totally relaxed in our presence, lounging around as if he owned the place. Sails aloft, we edged closer until we were less than 6m (20ft) away. He eyed us suspiciously but was far too comfortable, in the warm rays of the sun, to move. I took some beautiful shots of him, in fact, some of the nicest pictures of grey seal bulls that I have taken to date.

The loner, a grey seal bull hanging out all by himself. I really liked the patterns and colour of the calm water so decided to offset the seal a little to make more of them. Exposure was simple; the medium tone of the coat gave the same reading as my handheld light meter – for once it was a no brainer [Canon EOS-1v, 500mm f/4L IS lens, Velvia with 81A filter, f/5.6 at 1/250sec]

Photographing from boats

Working from boats is a fun experience but one that needs a little practice. As I knew that the seals would be very wary of us, I deliberately took my longest lens, the 500mm image stabilizer. I managed to set up my tripod on the deck, but on boats I usually use a monopod balanced on my foot, to reduce the effect of vibrations from the engine. The main problem with boats is that they move up and down with the motion of the waves, so I timed my pictures for when the boat was at the top of its rise and the motion was at its least. This meant using one-shot autofocus, as AI Servo would have been hopeless.

I need commercial shots to pay my way, but abstract ones like this are for my soul. I wanted to show the dark side of horses, the wild, untamed beast that is still inside. This was the client's chosen shot. Taken at the end of the day, I used a low aperture of f/2.8 to blur everything except the eye [Canon EOS-1v, 70–200mm f/2.8L IS lens, Velvia, f/2.8 at 1/60sec]

Choice of lens

The best lens to use for the job was my 70–200mm, f/2.8 image stabilizer, as it would give me the choice of taking a full-body shot or moving in for a tight head shot. I chose to load the camera with Fuji Velvia: as the images were to be used for advertising, it was likely that they would be used relatively large, so quality would be all.

Horse commission

Commissions are rare in this business. If someone rings up and asks me to shoot a commission, I usually think it's a joke. When I do get offered one, it is usually of the boring variety and to strict requirements; it is never 'Andy, can you go to the Caribbean for three weeks to photograph palm trees'. When this call came I knew it was serious as it was from an advertising agency that I had worked with many times before. The brief was to 'shoot horses in beautiful light' for a major client of theirs. This was

wide and loose enough to let me do what I liked. Tracey found me several helpful stud farms and we spent a week checking them all out. The most promising specialized in Arab horses; not only were the animals stunning, the farm was in the beautiful, rolling Devon countryside. I had never photographed a horse before and was forced to learn very quickly. My first lesson taught me that horses love to chew anything, including my camera rucksack and the top of my head. My second taught me not to lie down on the ground to

Head portraits

I quickly found that when taking a head shot of a horse facing straight on, I needed to use an aperture of f/11. The best angle to take a shot of a horse's head is about 30° to the body: as the horse turns its head, the muscles in the neck show. I also achieved much better results when using the lens at the 200mm end of its focal length, as this compressed all the facial features.

get a low angle: horses have a habit of running right over you. Finally, I learnt that horses are not fans of flash photography. I found this out the hard way, the result being that Tracey and I were almost stampeded. Oh what fun. And I thought this would be easy.

Working to a client's brief is tougher than it sounds. 'Horses in beautiful light' may sound easy but it meant that I had only a small window of time to shoot in – just before sunset. I understood this, Tracey understood it, even the local sheepdog understood it, but the horses were uncooperative and clueless. Tracey disappeared for a few minutes, leaving me to the mercy of the chewing hoardes, then returned with an umbrella. She is very experienced with horses and knows exactly what makes them tick. Ignoring my quips about the weather, she opened it out in front of the horses and it had a remarkable effect. In turn, each one

A commercial pose, with the ears up, and alert – a vital characteristic for horse photography. To negate the problems with the coat colour, I metered from my hand-held light meter [Canon EOS-1v, 70–200mm f/2.8L IS lens, Velvia, f/8 at 1/125sec]

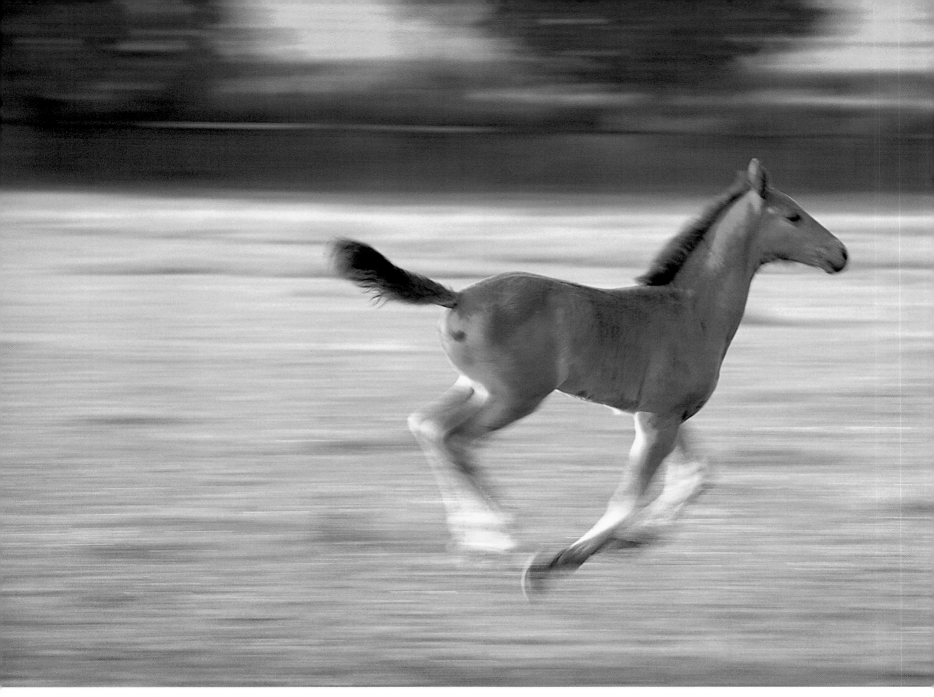

Using the same panning technique as I did with the tigers in India, I was able to show this foal just having fun [Canon EOS-1v, 70–200mm f/2.8L IS lens, Velvia, f/16 at 1/20sec]

raised its head, pricked up its ears, and gave a superbly attentive look. It must have added to the comedy for the stable hands watching as we walked up to unsuspecting horses and suddenly opened an umbrella in front of them.

We spent several fun evenings with the horses at a number of stud farms and after a while, I really began to enjoy my horse photography. It presented me with a new and exciting challenge, as I was effectively starting out, a novice in my field. It was nice to experience this again: feeling the buzz of achievement is something that can be lost in the commercial world I work in.

Camouflage

Camouflage is the art of blending into the background; it is a process, a way of thinking, rather than the donning of a single product. There are times when camouflage is essential, as with deerstalking, and times when it is simply helpful. In my previous month's exploits with fox cubs and hares I used nearby foliage to camouflage my hide and camera equipment; this is how I make myself a ghost in the forest.

I use RealTree clothing, which mimic's beech and oak woodland. There are now whole catalogues of camouflage clothing available, to mimic all kinds of habitat from ice-covered tundra to beech forest. The most important thing with such clothing is to match it to the terrain in which you will work. I use a Norwegian Fjall Raven mixed woodland outfit to blend with my local terrain. When buying new clothing, it is essential that you remember the following.

▼ Buy a complete set of matching clothing including jacket, trousers, gloves and headnet: one piece will not work without the others. Buy a loose-fitting jacket to allow for warm clothes underneath if necessary.
▼ Make sure the clothing is not Gore-Tex as this material is very noisy.
▼ Don't buy summer netting suits as these rip easily and are a waste of money.
▼ Threaten the salesperson with bodily harm if there is any Velcro on the suit. Whilst this wonderful invention is great for everyday life, it is awful for wildlife photography as it makes such a noise when opened.

All my camera gear, especially the lenses with bright white barrels, is also camouflaged. I use sticky RealTree tape with a piece of scrim net wrapped on top. The net is essential as the tape by itself does little to change the shape of the lens; it is useless stalking without it.

Gear box

Seals
▼ Canon EOS-1v HS camera bodies with NiMH drive × 2
▼ Canon 500mm image stabilizer lens
▼ 1.4× teleconverter
▼ Gitzo 1548 tripod with Wimberley head
▼ B&W 81A filters
▼ Fuji Velvia × 25 rolls
▼ Fujia Provia 100F × 15 rolls
▼ Hammock

Deer
▼ Canon EOS-1v HS camera body with NiMH drive
▼ Canon 600mm f/4L lens
Canon 70–200mm, f/2.8L image stabilizer lens
▼ 1.4× teleconverter
▼ B&W 81A filters
▼ Fuji Velvia × 15 rolls
▼ Beanbags
▼ RealTree camouflage clothing

When I am balancing in a high seat I use my longest lens and support it on a beanbag. When I am stalking, I use my lightest, fastest lens. With deer, more than any other form of wildlife, I need to be very aware of how I look in relation to the background, and of how I smell with respect to the wind. This is the essence of good fieldcraft.

It had been far too long since my last international trip and my long-haul feet were getting itchy. Although I really love being in the UK during summer, there is nothing like the adrenaline rush of dealing with animals that you know nothing about. This time I was off to Brazil. At the mention of a Brazil trip, most people imagine me venturing into the Amazon basin. From a biological standpoint this is the jewel, but in photographic terms it is very difficult terrain indeed, due to the thick tree canopy. I tend to visit one of Brazil's other gems, the Pantanal. This is one of the largest wetland areas in the world, home to some of the most diverse wildlife outside Africa and, as yet, devoid of tourists.

Spirit of the jaguar

Tripods and heads

A good tripod and head combination is vital for serious nature and landscape photographers. Tripods at the cheaper end of the market come complete with a head attached. These are great for holding a featherweight, disposable camera but not for much else. The right combination for your photography is almost as vital as the camera itself.

Tripods

Tripods come in many shapes and sizes. There is no single best buy, just the best for your photography. I use a Gitzo 1548 carbon fibre model because it is light enough to carry yet has a low centre of gravity, which means it is very stable even with a long lens on top. I know macro photographers who swear by the Uniloc/Benbo style of tripod, as it offers more flexibility than mine. The best piece of advice I can give is, buy the heaviest tripod you can carry, and the best-constructed you can afford.

Heads

Even more confusing is the range of heads available for tripods; pan-and-tilt, ball, fluid and gimbal are just a few of those commonly used. I have used them all, and each has its own advantages, but I now stick to two: an Arca-Swiss monoball and a Wimberley. The Arca-Swiss is simply a ball head that offers a lot of flexibility for landscape and macro work. It is small enough for me to pack in my rucksack and change to if necessary. The Wimberley is a suspension-type head, a specialist one for users of 400mm lenses and longer. It offers great stability and ease of movement, though it is a bit bulky to pack safely.

Awesome. The most aggressive and elusive of cats, the jaguar, and I love them [Canon EOS-1v, 500mm f/4L IS lens with 1.4× teleconverter, Provia 100F, f/4 at 1/60sec]

Gear box

▼ Canon EOS-1v bodies with NiMH drives × 2
▼ Canon 500mm, f/4L image stabilizer lens
▼ Canon 70–200mm, f/2.8L image stabilizer lens
▼ Canon 28–80mm lens
▼ Canon 17–35mm lens
▼ Canon 1.4× teleconverter
▼ Canon LC-3 remote camera trigger
▼ Beanbags × 2
▼ RealTree domed hides × 2
▼ Gitzo 1548 carbon fibre tripod with Wimberley head
▼ Lowepro Street and Field belt system with film pouches
▼ Fuji Velvia × 140 rolls
▼ Fuji Provia 100F × 60 rolls
▼ Fuji Provia 400F × 60 rolls

As the wildlife in Brazil is so shy I knew that I would use the 500mm lens for most of my shots, but took the others just in case. Unusually, I took two hides: I had needed hides for shooting giant otters the previous year but had neglected to pack any. I also took two spare beanbags as I knew that I would be doing a lot of work on a boat, where a tripod would be impractical. I always transport my beanbags empty – full, they weigh over 2kg (4½lb), which takes up valuable baggage weight – and fill them up, with sand, gravel, rice, beans or even clothes, when I arrive.

September's trip to Brazil was very tiring indeed and it took me a couple of weeks at home to recover my zest for photography. In the UK, this time of year is magical; the first frosts start to bite and the world is alive with autumn colour. I always try to spend some time in the UK during October, but this year my time was restricted by preparations for over seven weeks of travel, to be crammed in before Christmas. I decided to save on flight costs and combine two major trips, to Swaziland and Madagascar. Together they spanned the months of October and November, so welcome to a revision of our calendar – Octember!

October/November

Into uncharted territory

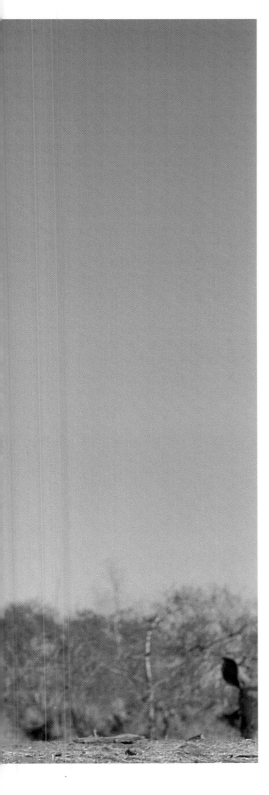

The first picture in this book taken with my medium-format camera, the Pentax 645NII. Rhinos are great characters and this mud-laden chap was fascinated by the sight of a strange figure lying underneath the Land-Rover [Pentax 645NII, 45–85mm f/4.5 lens, Velvia, f/8 at 1/160sec]

A change of direction

Reading this book, you may have noticed two of my characteristic techniques.

▼ Whenever possible I try to use my hand-held light meter to set exposures. This is not to pretend that I am some trendy photographer but a necessity, as my camera meter always seems to get it wrong. It is beyond me how this happens, and it has led to a lot of angry words between the manufacturers and myself – after all, it is hardly a challenging task.

▼ I try to show the animal in the context of its habitat instead of just taking tight head shots. The wideangle shots looked great through the viewfinder, but the resultant 35mm slides were disappointing.

The exposure problem was really starting to annoy me. I was making too many mistakes and missing too many good shots. Something clearly had to change or I would be strawberry picking within the month.

Medium format

I found the solution in an article about a guy who used a medium-format camera to take aerial shots. I had always thought of medium-format cameras as cumbersome and impractical, something that only landscape photographers used. But Mr Aerial took all of his work handheld and extolled the values of his particular camera, the Pentax 645. What really caught my eye was his statement that he trusted the metering; either he was completely mad or this Pentax was the answer to my problems. He also mentioned the autofocus capabilities of the system, something that surprised me as I thought medium format was a manual-focus world.

Being Andy Rouse has no advantages when trying to get a table at a plush restaurant, but when I rang Pentax it had a remarkable effect. I spoke to John, the marketing manager, who said they would be delighted to loan me a 645 system for my next trip. The next day it arrived with a letter explaining that this was a prototype of the new camera (the 645 NII) and asking, as it was the only one in Europe, would I please take care of it. Oh dear! I put that part out of my mind.

Using a medium-format camera is very different from using a 35mm one. For a start, you only get 16 exposures. This forced me to think about what I was photographing.

When my first set of films were processed I was disappointed to see that every picture was overexposed. Thinking that the Pentax light meter was at fault, I took them into John at Pentax who immediately showed me the data strip alongside each frame. The Pentax imprints all kinds of data and in the compensation field it read '0.7'. I had been so used to compensating the Canon meter

that I had done the same with the Pentax; so the meter was right and I had caused the problem. Hmmm. A camera I could trust. I never would have believed it.

There was no time for further tests as the day of departure had arrived. Challenging myself is something that keeps my photography fresh and my heart healthy. The next five weeks would certainly do that as we were working completely in the dark with animals that we had absolutely no experience of. I knew that rhinos were extremely dangerous when approached, and approach is what I intended to do, so it was with more than a little trepidation that Tracey and I waved goodbye to Muppet, our beloved cocker spaniel, and left for several weeks on the road.

Swaziland rhinos: walking tanks

First stop was a big game reserve in Swaziland, a really special place where rhinos are the stars of the show. Although I had no experience with them, I had plenty with the equally dangerous elephants and hippos, so I thought I knew what to expect. That all changed when we met our first rhino, within two minutes of being driven into the reserve. A walking tank stood in front of our vehicle, regarding us with the vacant gaze that is the speciality of the white rhino. It walked up to the front of the Land-Rover and started rubbing its horn against the bumper. 'Friendly chap isn't he?' quipped Mick, our guide and driver. I tried to force a smile and ignore the lurching of our vehicle from side to side. Thankfully, Land-Rovers, like rhinos, are built to withstand abuse.

Preparation

This was it. My first serious close-encounter test of the Pentax.

Camera and lens

I used a 45–85mm zoom on the Pentax 645NII with an 81A filter attached. From the low angle I knew that I would get a lot of blue sky in the picture (I had no idea how close the rhino would eventually come), so used the 81A to really bring out the colour of the sky and warm up the rhino's grey skin.

Film

I had pre-loaded the camera with Velvia; for blue sky it was the only choice.

Support

Testing the 645, I was amazed how stable it was to handhold. Getting a tripod underneath the Land-Rover was impossible, so I used a small beanbag on which to balance the camera.

Exposure

For once it was a no-brainer. The sunny 16 rule applied as it was cloudless and the rhino was lit directly by the sun. There are more books on this rule than there are liars in government but, once again, it states that, with ISO 100 film, in uninterrupted sunlit conditions, the medium tone reading is 1/125sec at f/16. With Velvia, which needs one stop more light, this means 1/60sec at f/16. I decided to shoot at f/8, which gives an equivalent of 1/250sec. This would be my light setting, but I decided to wait and see what the camera made of it all.

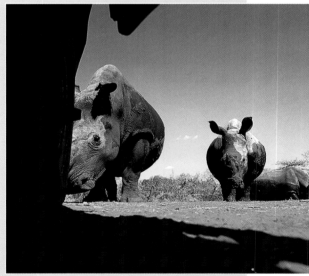

An idiot's-eye view of the rhinocerous approaching [Pentax 645NII, 45–85mm f/4.5 lens, Velvia, f/8 at 1/160sec]

The idiot in question, using a beanbag to support the camera in order to get the lowest angle possible [Taken by Tracey Rich]

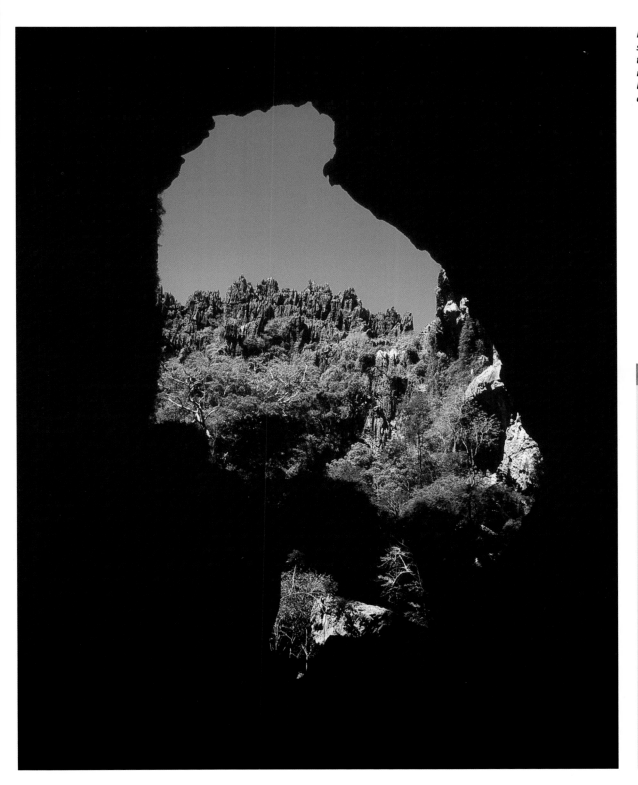

I really do like this picture – it took several minutes to compose and form the silhouette from the surrounding rocks [Pentax 645NII, 45–85mm f/4.5 lens, Velvia with Lee 81A filter, f/22 at 1/20sec]

In-camera duplicates

To warm up the reflected glow, I used a B&W 81A filter on the lens. A couple of rolls of Velvia ensured I did the scene justice. Film is the cheapest element of photography so I have no problem with shooting a whole roll of one scene, providing that I vary the exposure slightly between each frame. Of course, this is not always true. Sometimes I shoot the same scene three or four times so that I have enough originals to distribute to my agents. It just depends on the circumstances and whether I am Mr Jolly or Mr Grumpy.

Dancing in the desert: sifakas

After a few days I was raring to go again so we made our way south to the world-famous Berenty Reserve. As the plane banked sharply round on approach, I caught a glimpse of sandy beaches and what appeared to be sandy rivers. Great. We were going to Lemur-on-Sea. I hoped they had a good fish-and-chip shop. Many hours later, having travelled through an endlessly changing, parched landscape, we were suddenly surrounded by sisal, as far as the eye could see. This was the start of the Berenty Reserve, home to the ubiquitous ring-tailed lemur. However, my attention was captured by a lemur who danced in front of our vehicle as we arrived, dressed in a John Travolta white suit! This was a Verreaux sifaka, or dancing sifaka, as most people now know it.

 Sifakas are large lemurs, pretty much all white but with an odd bit of dark fur placed on the top of their head, like a peculiar toupee. Unlike their cousins, the indri, they are slim and monkey-like with long, straight tails. However, their most striking characteristic is not one of appearance. Sifakas have an unusual mode of moving from one feeding site to another. If the distance between trees is too great to jump, they simply run along the ground as fast as they can. But sifakas were not designed for running – a fact made all too apparent by their technique. They run sideways like a crab, using their flat feet, flailing arms and swishing tail to stay upright. Actually, if you have ever seen a fencing competition, or my attempts at the local disco, you will pretty much have the picture.

I had one chance to get this chap just as he was preparing to dance. The Pentax autofocus locked straight onto him, I trusted the exposure meter and took the last shot on the roll. I love the light on the spiny forest behind the sifaka and the way all his muscles are tensed and ready [Pentax 645NII, 300mm f/4 lens, Velvia, f/4 at 1/90sec]

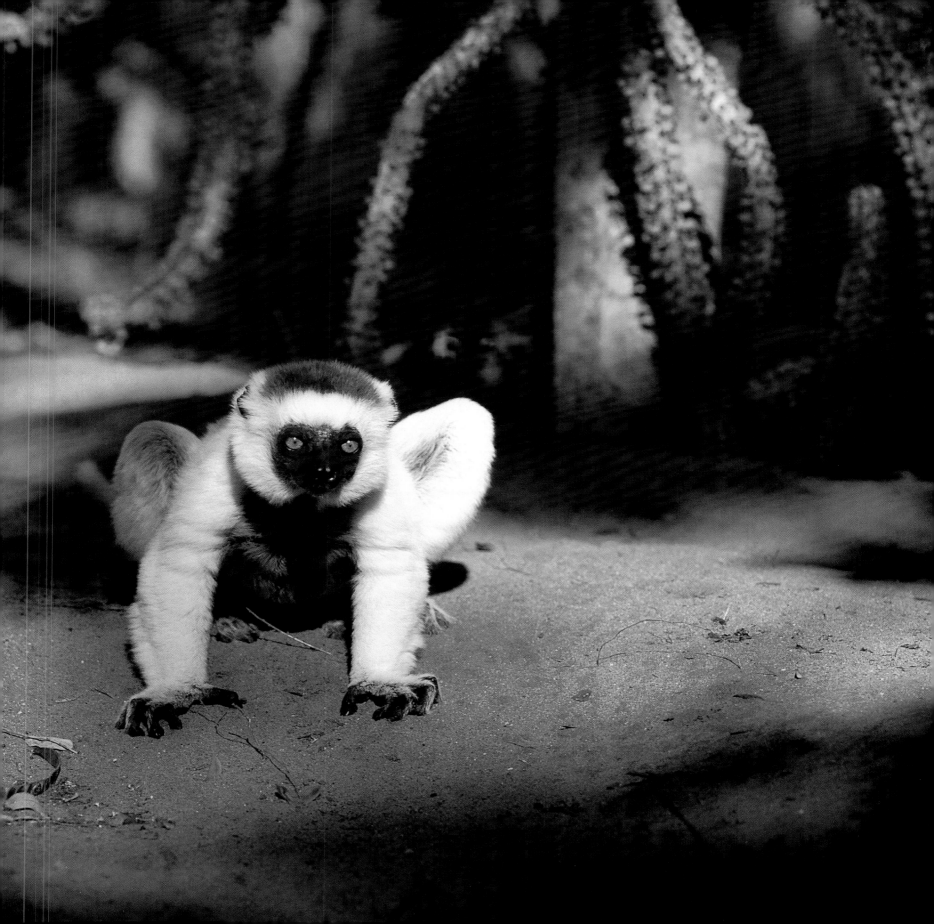

Capturing the dancing on film was a problem, as they seemed to dance only sporadically and without warning. Once again fieldcraft came into play; we spent the best part of a week working out their habits and patterns of behaviour. Sifakas are social animals and we learnt to recognize the home ranges of every troop and to predict when they would start moving according to the weather. When we got it wrong, which we often did in those first few days, we consoled ourselves with the ring-tailed lemurs. The ring-tails were used to humans, having been the subject of study at Berenty for the last 30 years. Gradually though, the sifakas also began to accept us, with two troops in particular becoming relaxed in our presence. The first was a nursery troop, with several babies attached, whilst the second was a bachelor party. The latter took a real liking to Tracey and always danced around her, which she enjoyed entirely too much. The best sequence of the trip came at a very unexpected time.

After a hard morning's dancing, we decided to grab some breakfast at the open-air restaurant. The food arrived, something masquerading as toast and a warm substance called coffee sat before me, and in typical bloke fashion I set about wolfing it down. Tracey stood up and pointed to the sifaka troop. I looked up to find they were now all in one tree, which could mean only one thing. They were getting ready to dance. Still munching toast we ran to the edge of the road to wait for them to cross.

We reached the edge of the road just in time to see two sifakas dance across in front of us. The mother and baby were next in line; I sat with my back against a tree and waited. After a final look she carefully climbed down from the tree, stood up, and started prancing across the road. The youngster held onto her back and as she took her final leap to clear the road, I was sure he was looking at me. I looked down at the frame counter; it showed four pictures. I hoped they were good. Luckily, they were.

Preparing for high action

One thing you learn as a wildlife photographer is to be ready for the unexpected. Thus, my camera was already set up and ready to go.

Exposure

I set the aperture to f/4 as I needed a high shutter speed to stop the dancing. I knew that the Canon meter was underexposing the sifakas so dialled in plus two-thirds compensation and set the autobracketing to one-third of a stop either side of this. I like to be well insured.

Autofocus

I set this to AI Servo (tracking focus) with all 47 points selected.

Film

The frame counter showed 25 so I had no hesitation in rewinding the film and loading in a fresh one. I often do this mid-roll as it is a lot better to have 36 shots available than 11. The white sifaka against the red sand made the film choice for me – Velvia. To get some extra speed I pushed it one stop to 100, which would cause a little loss of contrast in developing but not much else.

Camera

My only dilemma was over which camera to use. Over the past few years I have managed to get some fantastic action shots using the autofocus capabilities of the Canon system. However, I knew that the Pentax meter was more accurate and that the medium-format image would be more saleable than the smaller 35mm, but I had little experience of its tracking autofocus. I decided, on this occasion, to stick with what I knew – the Canon.

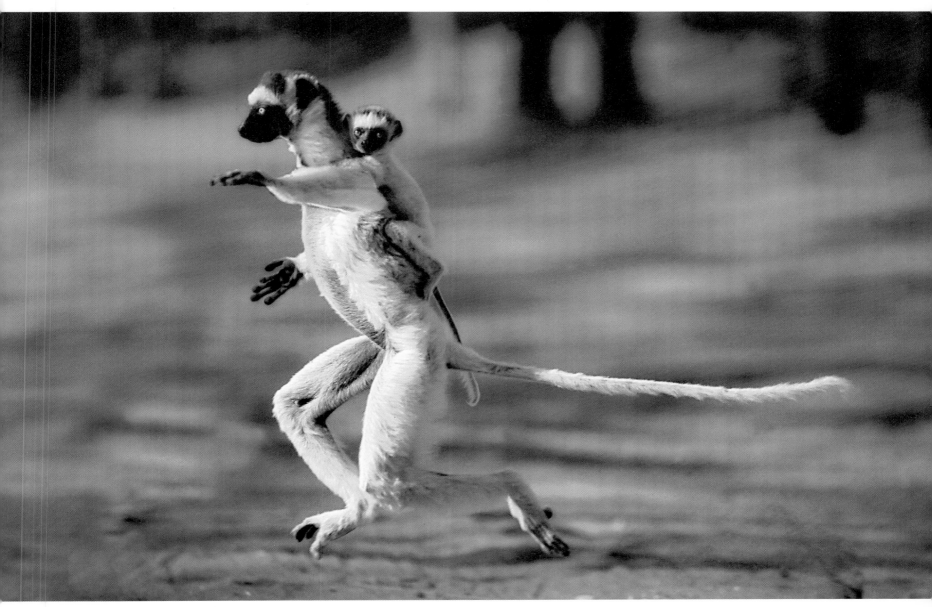

A nice low angle gave me the chance to show this mother leaping from the ground. At times like this you just have to trust the autofocus [Canon EOS-1v, 500mm f/4L IS lens, Velvia, f/4 at 1/125sec]

*The inquisitive youngster and the
stunning light combine to make this a
special shot [Canon EOS-1v, 70–200mm
f/2.8L IS lens, Velvia pushed to 100,
f/4 at 1/250sec]*

Gear box

Medium-format equipment
▾ Pentax 645NII camera body
▾ Pentax 45–85mm, f/4.5 × lens
▾ Pentax 300mm, f/4 lens
▾ Spare 120 film holders for
 Pentax × 4
▾ Fuji Velvia 120 × 120 rolls
▾ Fuji Provia 100F × 30 rolls

35mm equipment
▾ Canon EOS-1v HS camera body
 with NiMH drives × 2
▾ Canon 70–200mm, f/2.8L image
 stabilizer lens
▾ Canon 500mm, f/4L image
 stabilizer lens
▾ Canon Speedlite 550EX
 flashgun × 2
▾ STE2 Speedlite transmitter
▾ Lumedyne mini-cycler chargers
 for above
▾ Lee 81A filters
▾ Fuji Velvia 35mm × 30 rolls
▾ Fuji Provia 100F × 60 rolls
▾ Lastolite gold/silver reflector
▾ Gitzo 1548 carbon fibre tripod

This was the first time I had ever
had two sets of cameras. The
Pentax gear travelled in my
Lowepro Omni bag in the hold
whilst the remainder was
packed, with our clothes, in a
large army bag. As usual I took
the 500mm, an EOS-1v body,
half my batteries, and all my film
onto the plane with me. I also
took a small tool kit including
spare screws, bolts and tape etc
as my cameras always seem to
fall apart.

Second-sync flash

Perhaps this is best illustrated with an example. Imagine that I have been
commissioned to photograph the men's 100m final at the Olympic Games.
After watching the semi-finals, I decide that the coolest shot would be of
a sprinter frozen in mid-stride, with a blurred motion trail behind him. This
would show the athlete in full flow and the blur would give the impression
of speed. To create the blurred motion trail I need to use a slow shutter
speed on my camera, and to freeze the body of the athlete I need flash.

When I attach the flash to my camera and press the shutter, a sequence
of events unfolds. Most cameras fire the flash as soon as the shutter is
pressed; this is called first-curtain sync. In our Olympic example, the flash
would fire immediately, freeze the athlete in motion, then create the
motion trail for the remaining period that the shutter is open. One problem
with this is that the motion trail will appear in front of the athlete in the
final shot (think about it), which is great if you want him running
backwards. To get the motion trail behind the athlete I need to create it
first, then trigger the flash just as the shutter is closing. This technique
is called second-curtain sync and, in my opinion, it is the best option for
showing motion in still photographs. It is not a flash function but is
available on most modern cameras as a programmable option. I always
turn this option to second-sync.

Being on safari is exciting; there could be a lion or leopard around every corner munching happily away on something less fortunate. The waterholes abound with life, the plains, stretching to the horizon, teem with wildlife, and majestic birds of prey soar in the skies above. That is my dream Africa.

And finally ... to Africa

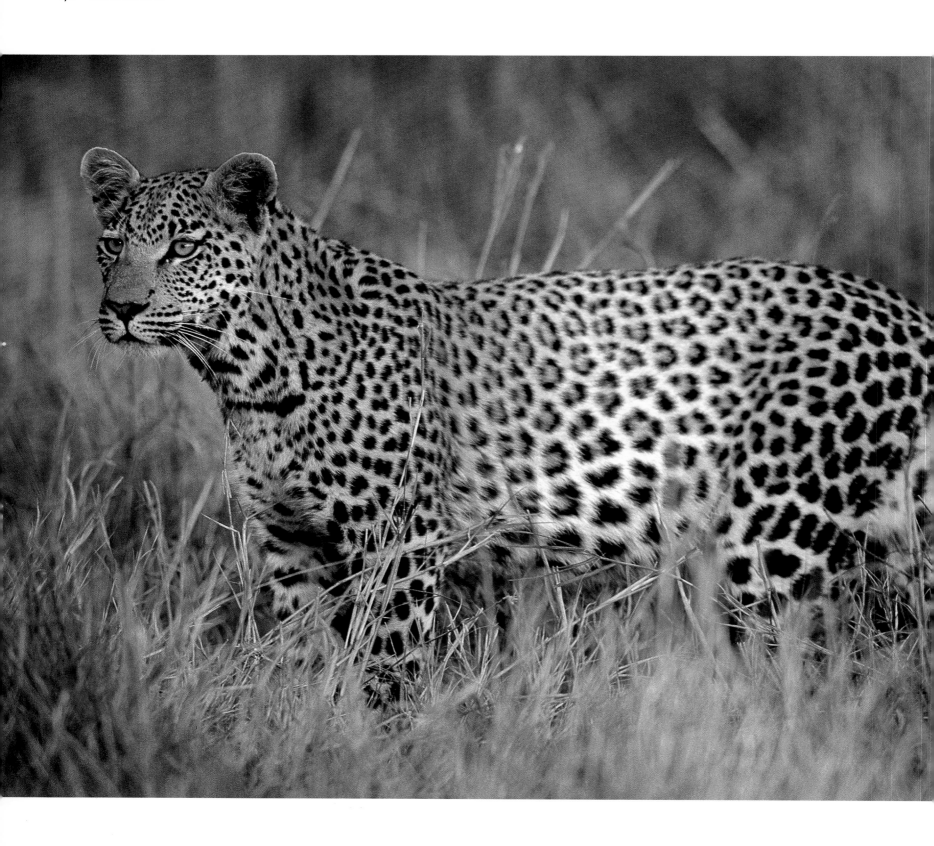

Most photographers who go to Africa want to get a picture like this. Nicely lit, good pose and relatively uncluttered. But Africa is more than just the big five, and in this chapter I have shown some of the less publicized jewels in its crown [Canon EOS-1v, 500mm f/4L IS lens, Velvia, f/5.6 at 1/60sec]

The reality

The reality is that Africa is now such a popular tourist destination, getting the ultimate safari experience is becoming harder. Destinations such as Kenya and Tanzania, whilst being fantastic for the safari tourist, can be very frustrating for the serious photographer. The animals are there in great numbers and are relatively tame, but there are also many people, in many vehicles, trying to find them. I had experienced this situation in India early in the year and have witnessed a cheetah kill in Africa alongside 27 other vehicles. That hardly makes for a wilderness experience. For my safaris I choose southern Africa. This is more expensive, but it is still very unspoilt and wild.

A trip to Africa is always a huge financial gamble for me as competition is fierce. There are a great many excellent photographers based in Africa, all of whom have the advantage of local knowledge and time. There is no point in my taking the same shots because the agencies will already be stocked to the brim with such material. I need to take different pictures, to choose different viewpoints. It is for this reason that I put myself in such life-threatening situations. My pictures stand out from the masses, which is vital, as I may only have a few seconds to impress a busy client with a tight deadline.

Africa has a huge diversity of species, all wonderful in their own right. I just love sitting and watching a herd of impala grazing, or wildebeest frolicking in the morning sun, and would much rather watch these than lions. Despite what we see on television, a lion's life actually consists of sleeping all day, to wake up just as the light becomes too poor for photography.

For most people, photographers and ecotourists alike, going on safari is a once-in-a-lifetime experience. Over the next few pages I hope to inspire you to explore the wonders that Africa holds, and to give you some idea of what to do there, so sit back and enjoy the Andy Rouse safari experience.

Lost baggage

It was with all this in mind that I arrived at the airport once again, ready for three weeks in southern Africa. The sky was grey and full of that annoying English drizzle, the stuff that soaks you to the skin. I was more than happy to fall into the airline's welcome embrace and be whisked away to sunnier climes. I had packed all my new Pentax medium-format gear in my hard Omni case, and this travelled in the hold with my tripod and other gear.

I watched as they labelled it all up, then boarded the plane and thought nothing more about it until, standing alone at the baggage carousel in Johannesburg, minus one piece, I had the feeling that something was wrong. 'Oh yes,' said the helpful girl behind the desk, 'we sent it to Münich by mistake, but we can get it back in two days' time.' I blew a gasket, venting my anger at the airline people. Is it such a chore to deliver baggage to the right place? I guess the more you travel the greater your chances of

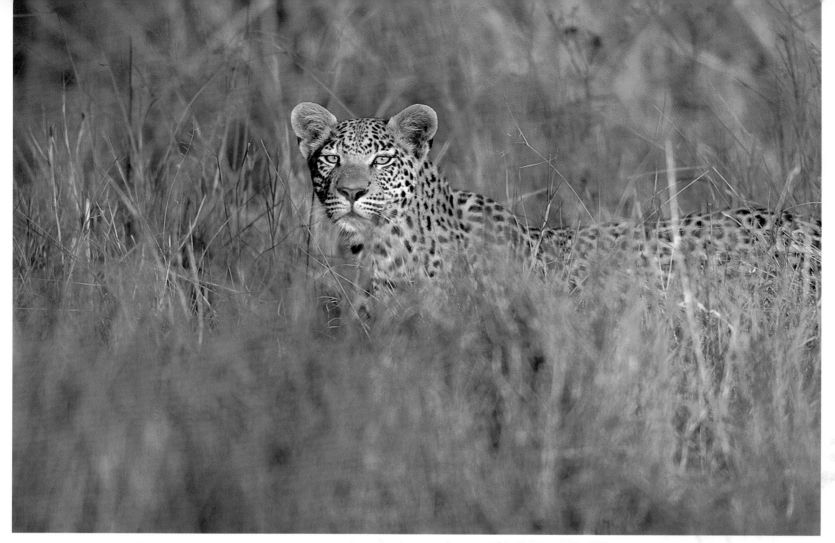

Deep in the grass, I waited for her to pop her head up and look at the human show. When she did I was ready with the autofocus, locked onto her, and for once trusted the meter as it could hardly get it wrong. An aperture of f/4 helped to blur the foreground and background, giving a more artistic feel [Canon EOS-1v, 500mm f/4L IS lens, Velvia, f/5.6 at 1/60sec]

experiencing this sort of thing. The big problem was that in two days' time I would be unreachable, in the middle of the bush. Delaying was not an option, so that was that. My medium-format gear, which I was so desperate to use, was not destined to come on safari.

Fortunately, I had my spare set of 35mm gear with me, though only one camera body as I had expected to be using the Pentax most of the time. I also had a problem with film; I had brought lots of 120 film and little 35mm, but a quick trip to Fuji in Johannesburg fixed that. I guess it was bound to happen to me sooner or later, but all was not lost.

I arrived at the campsite after two more internal flights, including one with the would-be stunt pilot that I seemed to attract all year. After a stressful day I had made it and, within minutes, was sitting next to a crackling campfire, sipping fresh coffee and staring at the unbroken carpet of stars. I felt myself unwinding.

The next day dawned clear and as we drove out of the camp I felt the exhilaration and expectation that only Africa can bring. I am very lucky to have experienced working on safari before, so I was set up and ready for the unexpected. Over the next few weeks we had endless encounters with wildlife, too many to talk about in this space, so here are some potted highlights.

Leopards

The best way of finding predators in Africa is to use the bush telegraph and listen for alarm calls from potential prey. Undoubtedly the best alarm callers are the guinea fowl. They sit in the treetops and berate anything below them that exhibits teeth and/or nasty intentions. Consequently, when we heard about 100 of them screaming their beaks off early one morning, we knew that something was going on. The thick bush prevented us from seeing anything, but we knew there was another track on the other side. The problem was that it would take too long to get there – there was no short cut – so we decided to get out and take a look on foot. Mad?

An intimate portrait of the cub, this works well as you are drawn to the eyes. This is absolutely vital for good animal portraits [Canon EOS-1v, 500mm f/4L IS lens with 1.4× teleconverter, Velvia, f/4 at 1/125sec]

Getting into position

I moved the beanbag slowly along the back shelf of the vehicle until I could rest my 500mm lens on it. The animal's head was at the top of the frame, so I selected the top focusing point of the camera to ensure that the head and eyes were in focus, under-exposed by one-third of a stop to bring out the colour of the coat, and chose an aperture of f/5.6 to minimize the distracting background. I smiled as I took my first exposure. This was the best leopard shot I had ever taken – in fact, it was my first.

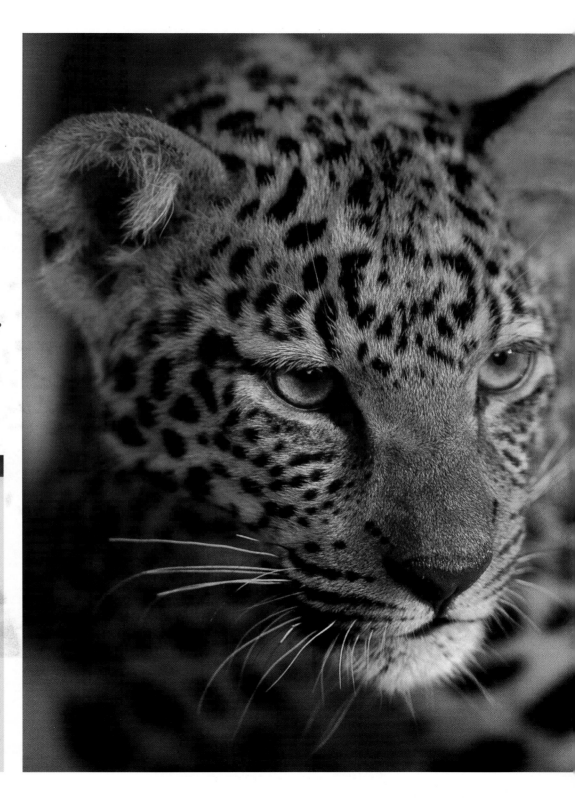

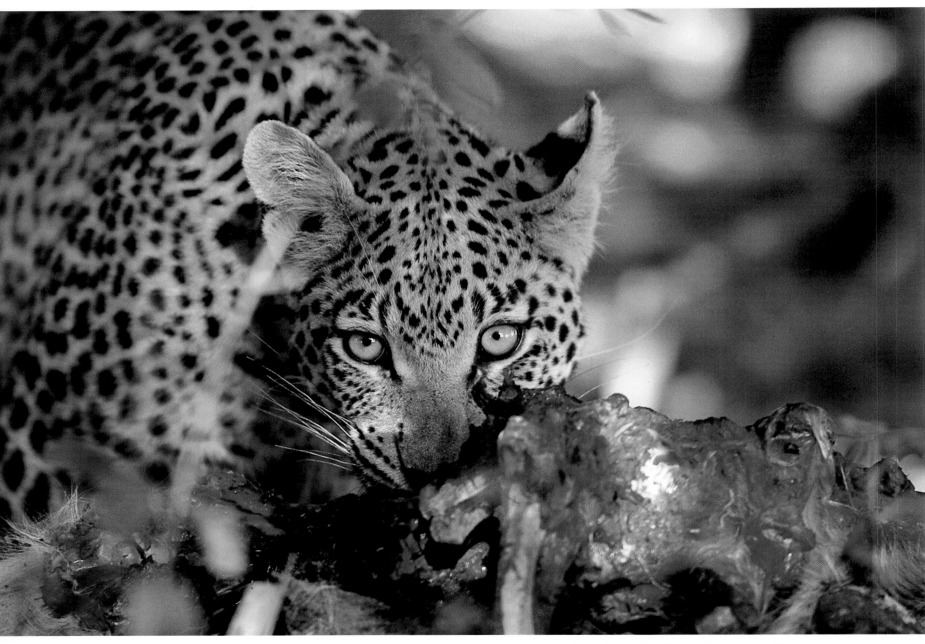

A less-than-perfect shot, as the grasses are distracting, but this is the usual habitat for leopards. A lot of my clients won't publish anything showing blood; I am not a gore merchant but this is a vital part of a carnivore's life – leopards do not eat broccoli [Canon EOS-1v, 500mm f/4L IS lens, 550EX with teleflash, Velvia, f/5.6 at 1/60sec]

Probably, but we had protection; each of us had scooped up a handful of grit. It may sound stupid but nothing annoys a cat more than being hit in the face with a load of small objects it can't see; if a cat charged, the grit could well save our lives. As we got closer to the bush, we could clearly see blood splattered all over the trees and our nostrils were assaulted with the fresh scent of death. Then I noticed the drag mark snaking into the bush; something heavy had recently been moved. A low cough warned us to keep away. It was a leopard and likely to be guarding its fresh kill. We backed off slowly, leapt into the vehicle and sped as fast as we could to the other side of the bush. We had found her, a female leopard and a mature cub with a freshly killed lechwe (local leopard fodder) stashed underneath a bush. However, we weren't the first witnesses to the scene. In front of us was a vehicle from the local lodge, Gametrackers', which had been lucky to be in the right place at the right time. It was filled with rich tourists (their lodges had chandeliers). We smiled at them, all dressed in the latest outdoor gear and wearing Gametrackers' hats. We nicknamed them Brainlackers, but only in private, as they always gave us nice chocolate biscuits for elevenses. Anyway, etiquette demanded that we wait our turn whilst they drove back and forth noisily, trying to get a clear view. We watched in frustration as we could see the mother becoming anxious. The leopard, clearly annoyed, retreated to the safety of the bushes and thwarted all their attempts at a peek. Eventually the tourists left. We munched on our biscuits and waited. But not for long. The youngster was at an inquisitive age and strolled out to take a look at her observers.

A growl from the impatient mother brought the naughty child back into the bushes, and the subsequent crunching of bone told us it was breakfast time for the leopards too. We edged the

Off-camera flash

This was a much more difficult shot: she was in the shade and there was only a narrow opening through the bushes. I would need to use the long lens again, but this time with a flash.

Exposure

I could see that she had the kill in front of her and by using the depth-of-field preview on the camera, figured that I would need f/11 to get everything in sharp focus. This would give a ridiculously slow shutter speed, which would certainly cause too much blur in the shot, so I decided to use f/5.6 and put the focus point on her eyes. The kill would be slightly out of focus but I figured that, providing the shot wasn't sold to a Gothic vampire convention, people would look at the leopard and not the kill. I trusted the camera's light meter implicitly (for the first time in months), as the leopard was in the shade and had a completely medium tone. It gave me a reading of f/5.6 at 1/60sec.

Flash

I knew that in daylight the range of my flash would be severely limited, so attached the teleflash adaptor. Using this accessory would certainly boost the power, but it would also boost the chances of green eyes. To negate this, I persuaded Gavin, my guide, to lean out of the vehicle and point the flash at the leopard from a different viewpoint. I test fired it and it lit up the leopard like a Christmas tree, so I dialled down the power by two stops. This time the effect was much better.

vehicle forward until we reached the bush; the leopard continued feeding about 6m (20ft) in front of us. The mother munched whilst we used our flash, then she moved slowly off, found a shady nook, and fell into a deep sleep. By now it was mid-morning and 90°. She would be comatose for most of the day, so we took it in turns to sleep in the vehicle. Leopards are dangerous and it would have been suicidal for us all to sleep, exposed, at the same time, but by staying with the leopards we would continue to gain her trust.

Around 3pm I was shaken awake from my slumber: our leopard was on the move. She had strolled through the grass to drink, with the cub following behind, but we knew she would be back so quickly changed position to keep the sun behind us. She returned from the water almost

Panning

The light in the clearing was getting lower and I knew it wasn't enough to freeze any motion, so I decided to shoot with a slower shutter speed, 1/15sec, and try to get some arty shots. I set the autofocus to AI Servo, lit up all the focusing points as usual, and panned the shot whenever the female started to run. I didn't know whether this would work, but it was better to try and fail than never try at all.

instantly, no doubt worried that we had a liking for rotting lechwe, and sat in the grass not far away. The cub was now in a playful mood and started jumping on her. I quickly changed to my smaller lens, and just in time, as they started to tear after each other, around the forest clearing.

By now the light had faded too much for any serious photography, and the sound of crunching gears in the distance announced the return of the Brainlackers' crowd. They rounded the corner to find us parked up quietly, feet on the dashboard, reading, with smug smiles on our faces. Their faces lengthened when we told them about the day that we had spent. I politely enquired after their lunch and was met with embarrassed looks in return.

We left them to their opulence and returned to camp in time to crack open a few celebration beers. Leopards can be the most frustrating animals to work with but today they had done us proud. We toasted their continued good health.

A slightly abstract shot in terms of composition, having the leopard running from one corner of the frame to the other. Fortunately it works, with her intent look and slightly curled tail adding to the drama [Canon EOS-1v, 100–400mm f/5.6L IS lens, Velvia, f/5.6 at 1/15sec]

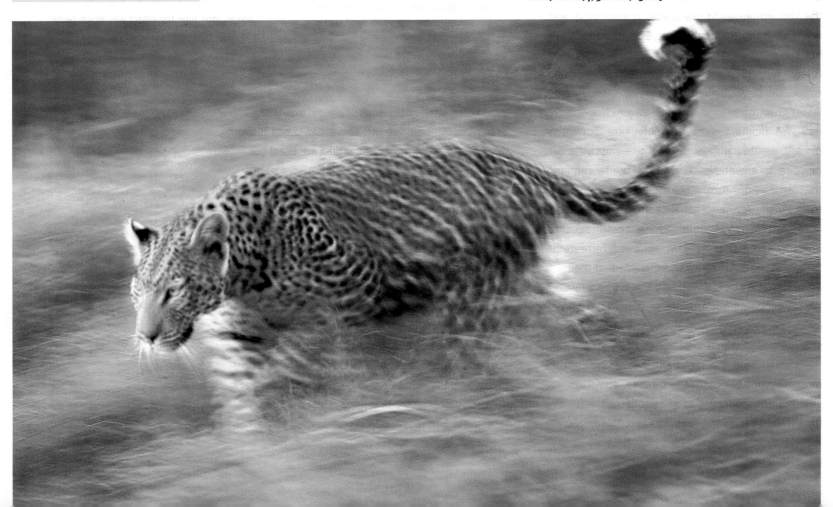

Hyena den

I awoke from a fitful sleep to hear something sniffing next to my head, on the other side of the canvas. 'Oh Spot, just go away,' I hissed. The sound of running feet and a cackle told me I had guessed correctly. This was hyena country and our campsite was too good for them to resist. We called all the locals Spot to make them less intimidating. Hyenas are not particularly dangerous animals but they are great opportunists and will gratefully nibble a foot protruding from a tent – and with jaws that can crush elephant bones, they deserve respect.

We'd had a pretty unsuccessful few days by our standards. We had found fresh wild dog, lion and cheetah kills but none were in a good place to photograph. One evening a pack of wild dogs brought down an impala close to our camp. Although it was too dark for holiday snaps, we decided to go and watch the free entertainment. It was the best decision we made all trip. A group of hyenas had gathered around the kill. One female caught our eye; through the binoculars we could see that her teats were enlarged. This meant that somewhere she had a den with youngsters inside, and we were convinced it was close. Come first light we were out at the kill. All the hyenas had left the party but there were plenty of fresh footprints heading back along the road towards the open plain. We followed slowly. Once we reached an area of open plain, we climbed to the top of the vehicle and scanned the horizon with binoculars. It was

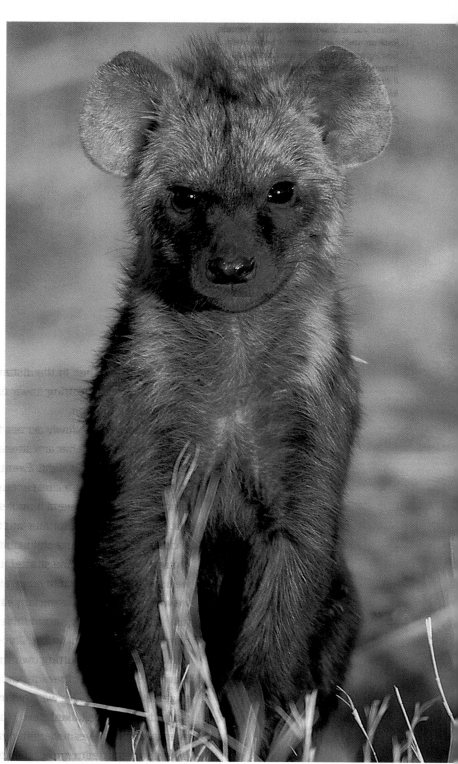

I used a 1.4× teleconverter to fill the frame with this lovely pup and locked the topmost focusing point right onto its eyes [Canon EOS-1v, 500mm f/4L IS lens with 1.4× teleconverter, Velvia, f/8 at 1/60sec]